THE ART OF MARY PRATT

Also by Tom Smart

The Art of Fred Ross: A Timeless Humanism

THE ART OF MARY PRATT
The Substance of Light

TOM SMART

GOOSE LANE EDITIONS

and

THE BEAVERBROOK ART GALLERY

Co-published by Goose Lane Editions and The Beaverbrook Art Gallery
with the assistance of the Canada Council.

Edited by Susanne Alexander and Robert Stacey.
Book design by Julie Scriver.
Printed in Canada by Hemlock Printers Ltd.
Photography by Ned Pratt, Robert Keziere, David Corkum,
Keith Minchin, Carlo Catenazzi, Equinox Gallery, Glasgow Museums,
London Regional Art and Historical Museums, Mira Godard Gallery
and the National Gallery of Canada.

Canadian Cataloguing in Publication Data
Smart, Tom
The art of Mary Pratt
ISBN 0-86492-173-X (bound) ISBN 0-86492-190-X (paper)
Co-published by the Beaverbrook Art Gallery.
Includes bibliographical references and index.

1. Pratt, Mary, 1935- — Criticism and interpretation.
2. Painters — Canada — Biography.
I. Pratt, Mary 1935- II. Beaverbrook Art Gallery. III. Title.

ND249.P7S62 1995 759.11 C95-950199-1

To M.A. and A.

This book was made possible through the generous assistance of
IRVING OIL LIMITED
to encourage art in Atlantic Canada.
Funding for this book has also been generously provided by
The Canada/Newfoundland COOPERATION Agreement on Cultural Industries.

This book has been published to coincide with the exhibition
The Art of Mary Pratt: The Substance of Light
organized by The Beaverbrook Art Gallery, Fredericton, New Brunswick.
Funding for the exhibition has been provided by
Marion and Harrison McCain
and the Museums Assistance Program of the
Department of Canadian Heritage

Acknowledgements

This book has benefitted from the help that I received from many people. I wish to express my appreciation to my colleagues at The Beaverbrook Art Gallery, Ian Lumsden, Caroline Walker, Greg Tracey, Angela Flynn, Marion Roussie, Lynda Hachey, Barry Henderson and Heather MacDonald-Bossé, who have helped to bring this project to fruition. Marie Maltais at the University of New Brunswick Art Centre provided a quiet space in which to write. Pat Grattan and Caroline Stone at the Art Gallery of Newfoundland and Labrador (formerly the Memorial University of Newfoundland Art Gallery) gave assistance in finding Mary Pratt's paintings in private collections in St. John's. Andy Sylvester at the Equinox Gallery in Vancouver and Mira Godard in Toronto helped in locating paintings and drawings in private and corporate collections throughout Canada. I am grateful to Susanne Alexander and Julie Scriver at Goose Lane Editions for assistance in editing, designing and publishing this book. Fred and Sheila Ross, Rex Murphy and George Fry gave insightful comments. I also wish to thank Robert Stacey, who read earlier versions of the manuscript and offered probing questions that clarified murky passages. In all this, I would like to express my appreciation to Mary Pratt and to her family, particularly Ned and Sheila Pratt, for their patience and invaluable assistance.

Contents

Preface

Irving Oil Limited has been collecting the work of Atlantic Canadian artists for many years.

We are fortunate to have some of the finest artists in the country living in Atlantic Canada. Mary Pratt, born in New Brunswick and now living in Newfoundland, is recognized as one of Canada's foremost artists, and deservedly so.

I have been an admirer of Mary Pratt's art since she first began painting. I am delighted that today her art is appreciated across Canada. This book will allow even more people to know and admire the art of Mary Pratt.

We are pleased to sponsor *The Art of Mary Pratt: The Substance of Light*. It is a fitting tribute to her and to the tremendous artistic talent in Atlantic Canada.

ARTHUR IRVING
September 1995

Director's Foreword

In the spring of 1993, following extensive consultation, stakeholders in The Beaverbrook Art Gallery formulated a five-year strategic plan. They placed near the top of their list of twenty-five objectives the development of a policy with respect to exhibiting art of national merit by New Brunswick artists, and using gallery resources to help New Brunswick artists achieve recognition beyond the region.

Although The Beaverbrook Art Gallery has, through its thirty-seven-year history, given prominence to New Brunswick and Atlantic Canadian artists in exhibitions and acquisitions, the quality and scope of *The Art of Mary Pratt: The Substance of Light*, both the publication and the exhibition, testify to the renewed strength of the Gallery's commitment.

In 1979, The Beaverbrook Art Gallery acquired its first work by Mary Pratt, the seascape *Entrance*, which the artist has described as a "first encounter," exploring new territory beyond her early still lifes. Through the generosity of Harrison McCain, The Beaverbrook Art Gallery acquired a representative painting from that still life period, *Peach Compote*, in 1995.

A major construction project in the early 1980s forced The Beaverbrook Art Gallery to cancel its showing of the Mary Pratt exhibition organized and toured by the London Regional Art Gallery, to the disappointment of the artist and her extensive Fredericton following. With *The Art of Mary Pratt: The Substance of Light*, the Gallery feels it has, in part, atoned for this lapse by offering readers and gallery visitors a comprehensive insight into the gestalt underlying Mary Pratt's substantial body of work. There

is an inherent irony in The Beaverbrook Art Gallery's celebration of this impressive photo-based collection. Visiting the Gallery was not one of the seminal Fredericton experiences which determined Mary Pratt's artistic path, simply because it did not exist at that time. Several years ago, Mary considered the possibility that if, as a child, she had had the opportunity to see great works of art "in the flesh" and witness the "facture" or brushwork of the old masters, her vision might have been very different. Instead, her initiation into art came through the reproduced photographic image as a tool of commercial artists.

The high regard in which collectors, institutions, aficionados and students hold Mary Pratt's work was reflected in the enthusiasm of potential funders, lenders and exhibition venues towards *The Art of Mary Pratt: The Substance of Light*. Without the financial support of Irving Oil Limited, the Canada/Newfoundland CŒPERATION Agreement on Cultural Industries, the Museums Assistance Program of the Department of Canadian Heritage, and Harrison McCain and the late Marion McCain, this publication and exhibition would not have materialized. As well, without the generosity of the lenders there would be no exhibition, and without the knowledge and expertise of our co-publishers, Goose Lane Editions, there would be no publication.

The linchpin of this project was the Gallery's curator, Tom Smart. The concept for the exhibition and publication were his. He procured the funding, secured the works, undertook the research and writing of the book, and collaborated with the artist and the publisher at all stages of the project, all the while maintaining a full curatorial load. It would be difficult to find a more profound advocate of the work of Mary Pratt, in particular, and the artists of Atlantic Canada, in general, than Tom Smart.

IAN G. LUMSDEN, *Director*
The Beaverbrook Art Gallery

to reach me is to burn first

you cannot come if you fear fire

— *Gwendolyn MacEwen, "The Cyclist in Aphelion"*

Chapter One

FREDERICTON

Light falling through the windows of Wilmot United Church in Fredericton bathes its interior in a soft opal haze the colour of April skin. Running along the ranks of pews, it transforms wood to pearl, plaster to ossein, brass to satin. Small cerulean blue rectangles the colour of a vein outline pillars, lifting the eye into the vaulted ceiling. Balls of red, blue and yellow dance from the unadorned stained glass windows whose plain circles glow in the warm humidity from the congregation. It is easy to imagine being under a boat: in a young girl's mind, Wilmot becomes a beached, ribbed vessel whose insides are caressed by a radiant presence, a muse. "The first blurred but persistent image I have," Mary Pratt recalls, "is of a block of pink, a rectangle of blue, and, to the left, a long black shape — my child's-eye view of my aunt's wedding ceremony."[1]

Pratt remembers being taken to church by her parents and spending many services marvelling at the different effects of light filtering through the windows onto the worshippers. She tried to imagine drawing the scene on the backs of her kid gloves, buttoned at the wrists; surely if she could see it, isolate the colours in the gloom of the church, it could be drawn? Drawing was, after all, "just putting a line around something . . . everything you see has a line around it."[2]

Mary Pratt and her art are not what they appear to be at first glance. She is more than an artist simply interested in transforming a domesticated life into myth, as so many writers would lead us to believe.[3] Over the course of her career and with increasing clarity and nuance, she has developed a myth of a radiant muse incarnated as light which induces vision. Her muse orders the world, then wanes, only to be reborn, trans-

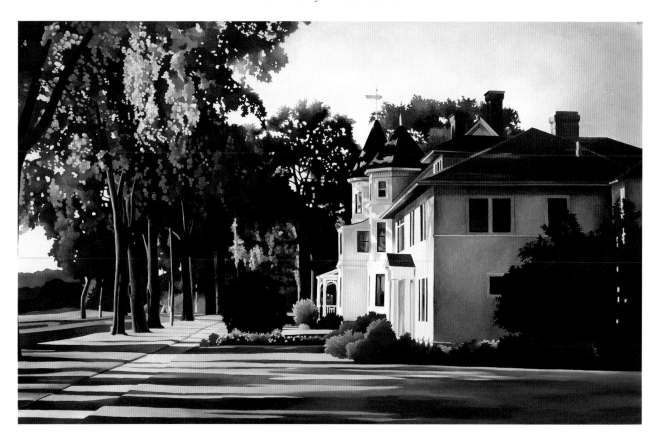

FREDERICTON, 1972
oil on board, 75.8 x 117.2 cm
Private collection

formed to begin the cycle again but never in the same form or substance. Pratt is concerned with translating her myth into her art, which is central to her life. Out of the gentle radiance of a still life or the fierce intensity of a fire, each of Pratt's paintings is a new beginning poised to metamorphose into yet another incarnation.

Tension in Pratt's art results from its ability to encompass seemingly disparate and divergent styles, themes and meanings within the pluralism of contemporary art. Her personal style, based on a mode of representation associated with photographic description, seeks to remove the expressive hand from painting. Yet, by embracing apparently styleless expression, Pratt creates deeply personal work, reflecting intense moments of experience. The apparent solidity with which she defines forms and their relationships to one another in space paradoxically extends from her intention to describe the intangible, numinous quality of light. Her ability to capture the distinctive features of a raking light or a diffused light at midwinter animates her interpretation of subjects and their many possible meanings. For example, by treating themes surrounding domestic rituals of killing, Pratt creates resonant metaphors of her society. An intensely studied still life exemplifies her extraordinary technical skill, while images of natural bounty are the central agents of a complex sexual drama. Moreover, her art, which appears to array the visual experience into elaborately rational pictorial schemes, gives coherence and meaning to her life and to her emotional landscape. Art conditions her life, and her life adds subject and texture to her art.

Mary (West) Pratt was born in 1935 and raised in Fredericton, New Brunswick, where she first realized that life would affect her most passionately through her eyes.[4] She realized early that her visual memory was better than that of her friends and that she ordered her world visually. Her earliest memories are of the warmth and quality of the light that enveloped festive events or bled through the windows of her parents' house. Mary's world included a playhouse, a sandbox, a swing, roses and delphiniums tall enough to blend with the sky, and the Saint John River, which always reflected the blues, pinks and golds of daylight or the deep ultramarine and silver of night. Looking back, Pratt writes, "It seems to me now that the Fredericton of my childhood was all pink sidewalks and green lawns, purple roads and great dripping trees."[5] She recalls the faded chromolithograph in her parents' home showing the young Samuel, radiant in a shaft of light streaming down on his head, with the caption, "Speak, Lord, for thy servant heareth." As a child, Mary waited for the same, believing that it was possible to be "spoken to," that God would call her to a vocation.

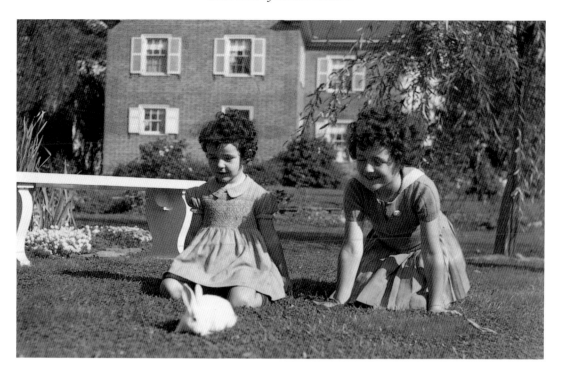

Mary lived in a world where she was accepted and admired, loved by parents and relatives who kept pleasant homes that shone with a well-rubbed charm. People did not talk about furniture or rugs or wallpaper in the Fredericton of Mary's childhood. These were simply backdrops on the stage of an operetta as neatly divided into acts as was Fredericton society and politics of the 1940s. Her childhood was privileged. She was the daughter of a prominent lawyer, who later became the province's attorney-general. William J. West was himself an amateur artist who recognized the importance of art, beyond mere decoration, to society. West doted on his two daughters, Mary and Barbara, building for them in the backyard a child's idyllic world, centring on a playhouse. He also constructed a pint-sized replica of his own house as a dollhouse for his daughters.

A Methodist and later a reluctant United Church member, West believed that his life was in God's hands. His faith was born amid the horrors of the battlefields of the First World War. During treacherous reconnaissance missions, running the gauntlet through mud on sinking duck-boards, he would utter the words, "And He shall give His angels charge over thee to protect thee in all thy ways." He saw in his survival a covenant to be fulfilled through public service. Later, West instilled in his daughters a sense of rights and duties, of serving one's community and holding to one's beliefs, almost to the point of appearing haughty.

Mary (right) and her sister Barbara in Fredericton, c.1941

West's world was orderly. Religion, politics, law and art provided manners governing conduct; to live without them was to allow the intrusion of chaotic forces whose most grotesque expressions he had witnessed in a Belgian trench. Order (and good government) flowed from faith, from assertiveness, from discipline and from tolerance. These articles of behaviour gave West's life an armature. They provided him with standards of civility that he could recreate in Fredericton, at times with a heavy hand — he was responsible for instituting the "Fredericton Curfew" during the Second World War, which banned anyone under sixteen from the city's streets after 10:00 p.m. His discipline and rectitude, Pratt affirms, "denied me a lot of fun . . . and caused me hours of frustration, but they allowed me my painting."[6]

Mary's mother Katherine was a disciplinarian who kept the peace between her husband and her own mother, Edna MacMurray. Katherine West taught her daughters the power of the non sequitur to diffuse awkward tensions between people. She worked for a horoscopist who predicted that Mrs. West's life would be woven into the fabric of the lives of prominent people. Mrs. West's dour Presbyterianism balanced her husband's Methodist need to make a contribution to society. Mary's mother taught her that the world was never as it appeared on the surface, that at the edges of human relationships much was left unsaid. This was particularly true of her own past, which she kept sealed from her daughters. Mary's grandmother, despite greatly reduced financial circumstances in her old age, showed her comportment and dignity in the midst of a sea of whispers. Although there was a good deal of friction between West and his mother-in-law, Edna MacMurray showered on Mary the affection usually reserved for the favoured grandchild.

Growing up secure within the precincts of her parents' cosmos, Pratt lived in her imagination. The Fredericton that Pratt's parents gave her set her identity. The Fredericton that she created for herself had strong lights and deep shadows. Pratt was fascinated by the annual post-Christmas bonfire ritual that punctuated and concluded the holiday in Fredericton. Fire had a cleansing finality about it. The Christmas tree pyre drew to an end the fuss of the season, turning it into smoke, heat and blinding light that inevitably were beaten by the deadening cold of January nights on the banks of the Saint John River. Her Fredericton included the butcher shop on King Street. She would watch the chickens being cleaned every Sunday, see the birds being transformed into inanimate carcasses, hear and smell feathers being seared, feel the rubbery skin with nodules of fat clinging to its webs. The running of water, the rising of steam,

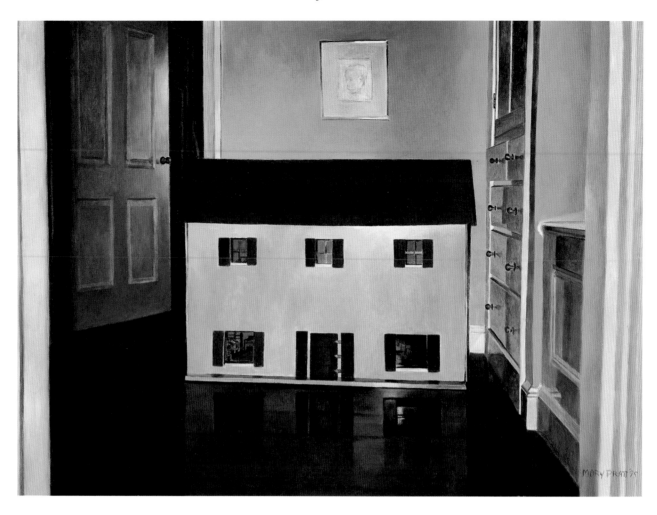

THE DOLL'S HOUSE, 1995
oil on linen, 45.7 x 61.0 cm
Collection of the artist

Opposite: MY PARENTS' BEDROOM, 1995
oil on canvas, 91.4 x 61.0 cm
Collection of the artist

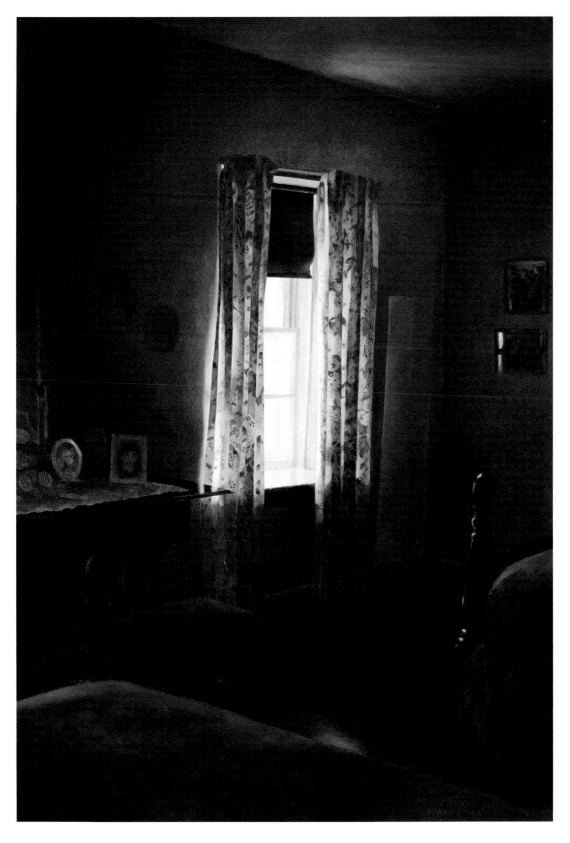

the trails of smoke, the remains of an exploded and burnt horse, the violation of a young woman in front of a park bandstand were as much a part of the Fredericton of Pratt's childhood as were the delphiniums and lupines.

Art provided Mary with a gentle analogue of the propriety which ordered her father's and mother's lives. Drawing and painting came easily to Mary, and her aptitude was encouraged by her parents. In fact, at times she felt forced into developing her natural talents by a sequence of art lessons offered by several art societies and individual artists, and through the University of New Brunswick. When she was in grade seven, one of her drawings won first prize in a local amateur art club competition and was included in an exhibition of children's art in Paris. But it was not until she was fifteen years of age that Mary received her first formal training in art in summer classes and workshops taught by a group of artists who established the Art Centre at the university. For Mary, it was a tentative first step into the world of professional artists. When she went up the hill to the university, she had the distinct feeling that she was walking into another camp.

The Art Centre was formed by a group of artists who perceived a need to fight complacency about art and the ingrained attitude of its amateur status sustained by the many different art societies and clubs in Fredericton. Opened in 1941 by Lucy Jarvis, the Art Centre was the first independent campus art centre in the Maritimes.[7] It became a conduit for artists in both Fredericton and Saint John who wanted to be exposed to the current trends in painting and to learn something of the intellectual and practical underpinnings of abstraction.

The Centre's birth was a product of the Kingston Conference held in the summer of 1941 at Queen's University. Speakers at the conference told artists to return to their hometowns and create art with a clear social message, to paint large-scale murals similar to those of Works Progress Administration, Federal Art Projects (WPA/FAP) artists in the United States, which depicted the struggles of workers to achieve material and spiritual fulfilment in a world depleted by the Depression and torn apart by war. The belief that art could be a cornerstone in a new society was also at the heart of the impetus to establish the Art Centre. Lucy Jarvis and one of the earliest sessional instructors at the Art Centre, Pegi Nicol MacLeod, attended the Kingston Conference and returned to Fredericton determined to change its citizens' attitudes about art.

Fritz Brandtner was one of the early art instructors at the Art Centre. He taught Mary in the summer of 1950 in classes that briefly covered concepts of describing space abstractly by using line, form, texture and movement.[8] By exploring two-dimensional space, Brandtner encouraged her to think of it not simply as negative form, but as a solid mass that could be an integral component of abstracted compositions. For Brandtner, studying space in this manner allowed his students to conceptualize non-objective design from nature, objects or memory. Mary never felt completely connected to his teaching, perhaps because Brandtner saw in the mission of art education the means of enriching the lives of the underprivileged, which Mary most definitely was not. However, she was drawn to the work of Goodridge Roberts, a visitor to the Art Centre in the early 1950s and, in 1959, its first resident artist. In Roberts's work, rather than Brandtner's, Mary was better able to see how negative and positive spaces could be used as formal elements of a composition to establish flat, abstract harmonies.

Mary was cautioned by her father about the politicized nature of the artists at the Art Centre. "I understood that the university crowd was subversive," she recalled.[9] Indeed, the extent of division among various factions in the city was best expressed in the difference between the politics of the university and the politics of the province. The two rarely mixed. The conservatives in town and the communists on campus viewed each other across an ideological chasm of suspicion in an era of Cold War tension. In art, the rift was exemplified by the differences in modes of representation. To some, abstraction was symptomatic of the failure of society and a wilful disregard for the historical past. To others, naturalism descending from the Old Masters was a tired form of academicism that had lost any relevance or meaning in the new society being constructed after the war. The minor striations that Mary saw in Fredericton's art world represented a microcosm of the craggy polemical terrain of abstraction and naturalism in Canada and the United States.

Even as a young woman, Mary shunned cliques. She was not drawn into the circle of artists and their acolytes at the Art Centre, preferring instead to be aloof, on the edge of a dynamic experiment that was introducing modernism to Fredericton. Mary remained suspicious, questioning ideas about the social aspects of art and its use in asserting a political ideology or social agenda. Her classes at the Art Centre were balanced by others given by John Todd, a graphic artist and illustrator who set up a small studio serving the printing presses of Fredericton. Trained in New York at the Pratt

Institute, Todd brought to Fredericton an appreciation of photography as a source of images in the commercial art business. Mary's early studies in art were, therefore, not at the well of art-historical antecedents and the "Great Masters," but from the mirage of commercial advertising and graphic art that she was exposed to in Todd's studio. As a sixteen- and seventeen-year-old, Mary went to his studio for lessons every Friday evening. Todd urged her to keep a file of photographs, clipped from weekly news magazines, as a source of images for her art. They provided illustrations of different compositional formats, from the single point of view to collage and montage; they made use of the wide spectrum of photographic techniques — close-up, wide-angle, distortion, displacement of scale and others. The ideas and concepts that Mary absorbed from these sources descended from images of desire, from the panoply of illusory worlds that post-war industrialization promised. Images serving the seductive enterprise of creating expectations based upon ownership gave shape to her earliest ideas about the artistic image. She was attracted to their ephemeral promises of sensual delight — a property as much of the depersonalized nature of their presentation as of the technique of their rendering. That there were no brushstrokes apparent beneath the glossy surfaces of the offset and varnished pages mystified the young student.

Had Mary been presented with the opportunity to balance her early art education with the study of original works of art, she might have become aware of the unique qualities of paint and drawing media. But in the Fredericton of the early 1950s, there were few occasions to see original works of art. A room in the basement of the Normal School sometimes doubled as an art gallery; there were infrequent travelling exhibitions and there was no public art gallery with a permanent collection. Mary's only opportunity to visit art galleries occurred during brief holiday visits with her family to small coastal towns on the eastern seaboard of the United States, where she first saw paintings by Andrew Wyeth, Winslow Homer and George Bellows.

Although Todd suggested that Mary should attend the Art Students' League in New York, or even the Pratt Institute, after she graduated from high school, it was out of the question for her to study art anywhere else but at Mount Allison University in Sackville, a three-hour drive east of Fredericton. Her father had been a member of the Board of Regents and the chairman of the alumni association. In 1953, when she was eighteen years old, Mary West enroled in the Bachelor of Fine Arts programme at Mount Allison University.

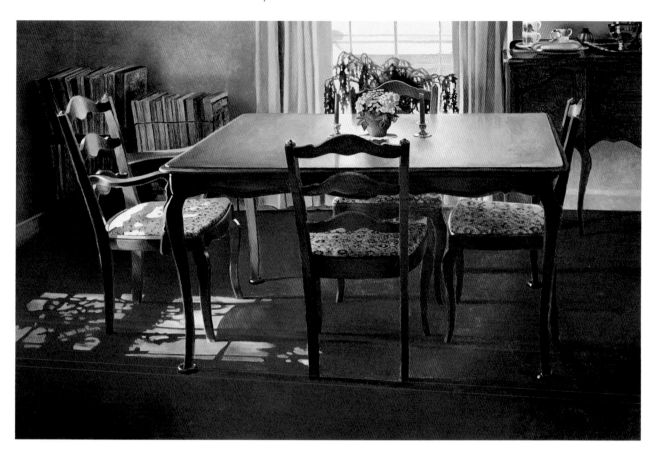

THE DINING ROOM WITH A RED RUG, 1995
oil on linen, 91.4 x 137.2 cm
Collection of the artist

Chapter Two
MOUNT ALLISON

The tenets of the University of New Brunswick's Art Centre were to use art to develop the mind and to comment on society; the purpose of the curriculum of the School of Fine and Applied Arts at Mount Allison University was just the opposite. Brandtner, Jarvis and their colleagues at UNB interpreted nature through art; they did not imitate nature. "Art comes from character and personality more than from theory and imitation of nature," wrote Alan Gordon, a photographer and student at the Art Centre in the early 1950s.[1] In contrast, Mary West and the other fine arts students at Mount Allison were given a solid grounding in the technical dimensions of painting and drawing before proceeding to interpretive or abstract modes. The department's reputation was based on an approach that taught technique almost exclusively, divorced from any context that lay outside the work of art. At Mount Allison, art was considered its own reality, a system of processes and techniques, skills and abilities learned and applied to solve formal and technical problems associated with visual representation. Art was presented as a mode of communication, not as an agent of social engagement. The curriculum reflected a "compromise policy between the strictly academic and the schools of free expression." The fulfilment of this policy rested in the hands of the three professors in the department: Alex Colville, Lawren P. Harris and Ted Pulford.[2] The School of Fine and Applied Arts that Mary walked into in September 1953 was stirred by the sensibilities, talents and jealousies of these three men.

When Mary stood in front of Professor Colville while she was registering as a first-year student in the Bachelor of Fine Arts degree programme, she remembers worrying

that her fate was to become yet another Sunday painter or a member of one of the many art societies scattered around the province. Colville reassured her that this would not be the case with her; indeed, his faith lay in a regimen of instruction that was guaranteed to bury amateurism in professional rigour. Mary's first year was "fundamentally composed of Drawing, Painting, Design, Mural Decoration, and a study of the History of Art and Appreciation of Painting."[3] Although the programme was intended to provide a basis for students wishing to specialize in commercial art or industrial design, or to teach art, many students including Mary believed that they were studying in the best professional art school in the country. Mount Allison's academic dimension elevated the School of Fine and Applied Arts above its rival, the Ontario College of Art. Mary also knew that the added advantage of her art school lay in its professors; she knew that she was fortunate to be studying under Colville, Harris and Pulford.

Colville was no stranger to Mary. Her father had had a hand in convincing Mount Allison to hire Colville after he returned from war service. Believing the young war artist to be supremely gifted, West did what he could to ensure that Colville could sustain himself and his young family in the Maritimes. West had also been instrumental in securing the commission for Colville to devise a decorative scheme for the interior of Wilmot United Church in Fredericton. Colville's design took advantage of the quality of light that entered the church from simple stained glass windows in a clerestory onto the congregation, neatly segregated in box pews that resembled egg-crates. Colville added a simple cerulean blue coursing of small rectangles which outlined the columns and window wells of the church's interior. The effect lightened the inside, lifting the eye heavenward. It also created a simple, elegant balance among the architectural elements of the church. Sitting in one of the side-aisle pews, as Mary and her parents did each week, one could easily imagine being transported into the enigmatic stillness of one of Colville's paintings.

Colville himself had graduated with a BFA degree from Mount Allison in 1942, shortly before joining the Canadian Army, which eventually appointed him an official war artist. At the time of his graduation, the university's art school, housed on campus in the Owens Art Gallery, had achieved an enviably good reputation under its British-born director, Stanley Royle, for the quality of its professional instruction and the calibre of its graduates.[4] Royle retired in 1945, and he was replaced briefly by the

Montreal-born artist T.R. MacDonald. Then, in 1946, Lawren P. Harris was named head of the Fine Art Department and director of the School of Fine and Applied Arts, the same year that Colville was hired as an assistant professor of fine arts. Harris quickly ushered in a series of reforms based largely on the energy of the professors, their abilities as artists and teachers, and the synergy among the faculty and students. Mary and her peers were among the beneficiaries.

During the summer of 1949, Harris toured art schools in central Canada and the United States to

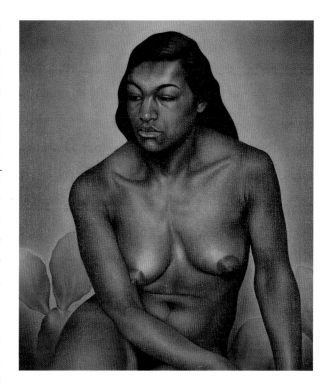

develop new courses and modify the existing curriculum in the area of fine and applied arts.[5] Later in the year, Harris and Colville were joined on staff by Ted Pulford, after his own graduation from the school. That by the early 1950s the department could boast "facilities unequalled elsewhere in eastern Canada" is largely due to Harris's work as head of the department.[6]

Lawren P. Harris was a practising artist in his own right. The son of Lawren S. Harris, a founding member of the Group of Seven, the younger Harris received his early training in art at the Boston Museum of Fine Arts. From 1936 to 1940, he taught art in Ontario. Shortly thereafter, he joined the army, serving in a tank regiment before being appointed an official Canadian Army War Artist (with the rank of captain) and posted to Italy.[7]

The foundation of Harris's art, no doubt extending from an intimate appreciation of his father's mystical abstractions, rested on his innate understanding of underlying rational structure, abstract form, dynamic planes, and the expressive potentials and emotive qualities of tones and hues. His service in Italy earned him the unique reputation as the only Canadian war artist who responded poetically to what he witnessed. His

Lawren P. Harris, NEGRESS, 1937
oil on canvas, 76.8 x 64.1 cm
Collection of The Beaverbrook Art Gallery

paintings were described as "contemplative," expressing the war as if it was "a dream."[8] Marrying this ingrained artistic sensibility to interpretations of tank combat, Harris produced paintings that depicted an absurdly complex choreographed theatre of grotesque wastefulness of men and machines. Crisp linearity and attention to volumetric form imbues Harris's war paintings with a sense of surreality, comparable to Salvador Dali's paranoiac images from his unconscious. Harris looked at the capacity of the machinery of war to dehumanize confrontation. In his cool, detached observations of battle, its slaughter and destruction, Harris simplified forms by eliminating details and organizing his compositions rationally and geometrically.

Harris's process of reducing and simplifying forms was carried over into figure painting. His personal style of figuration, seen for example in his 1937 painting *Negress*, gives his introspective figures a strange exoticism, perhaps reflecting his own contemplative sensibility. By the late 1940s, Harris was unmatched as a technician. He was one of the more competent painters of formal portraits in Canada, a form of painting demanding exactness in conveying both the likeness and the character of the sitter. Unlike his war work, his formal portraiture demanded an ability to paint in a naturalistic mode of representation, to imitate nature in paint.

Mary West and her classmates at Mount Allison in the early 1950s knew Harris as a "slow, deliberate" artist.[9] He "roamed from realism to abstraction and back again at will," while demonstrating to his students a mastery of technique. Yet he subordinated technique to the expression of ideas.[10] Harris preferred abstraction. "I have been led into abstract painting," he wrote in 1954, "where I feel it possible to achieve a clearer precision of meaning. . . . My aim is to express myself by the most forceful yet purest and simplest statement." Harris's approach to interpreting his subjects unfolded from an intense perceptual process that heightened awareness, leading to what he referred to as "clarity" and "vision." By looking through nature to its organizing principles, Harris sought to emulate the work of the Dutch painter Piet Mondrian by exploring the "dynamic interplay of feeling and reason which gives the design of . . . a painting its fullest meaning." Mondrian was able to reveal this interplay through the process of abstraction extending from intense observation of nature and the gradual reduction of vision to pure form. Harris adopted this perceptual process in his own painting, which, in turn, provided a foundation not simply for his art, but also for his life, demanding of him "a great degree of self-discipline." For Harris, freedom of expression was made possible by a disciplined eye and mind and a controlled life.[11]

By the mid-1950s — during the time that Mary was a student — as went Harris, so went Mount Allison's School of Fine and Applied Arts.[12] The self-discipline that ordered his art and life appears to have guided the constitution of the school's curriculum as well. Under his tenure, the school formalized a policy of providing students "with a sound, fundamental grounding of an academic nature, before allowing [them] the widest freedom of individual expression."[13] It balanced courses in the humanities with courses in artistic technique. Indeed, the four-year programme that Mary found herself in reflected Harris's own philosophy. In her freshman, sophomore and junior years as a fine arts student, she was drilled in the basics of drawing, design, sculpture and working from the still life before she was allowed to move on to a less-structured senior year. Freedom of expression was earned only after she had trained her eye and mind over three years of schooling in which her imagination was educated.

While Lawren Harris's personality shaped the curriculum, Alex Colville's dominated the minds of the students. To the young Mary West, "Alex Colville appeared as normal as an insurance agent."[14] Yet he also had an air of accomplishment — a charismatic presence that blended intellectual prowess, creative accomplishment and personal demeanour. In his studios, Colville appeared every inch the military officer he once was. His students were formal without having to be told to be so. They showed a respectful courtesy to Professor Colville, whose reputation as an accomplished artist was rising by 1953 because of his unmistakeable "magic realism."[15] In the Canadian context, magic realism seems wholly the domain of Colville's art. However, it originated from the *Neue Sachlichkeit* (New Objectivity) movement in Germany during the 1920s, when it was born as a critical reaction to the political and social turmoil of post-war Germany. The 1943 exhibition entitled *American Realists and Magic Realists* at the Museum of Modern Art in New York attempted to define the contemporary American Realist movement by codifying it under two broad categories: sharp-focus painting, which strove for "precise representation," and magic realism, which was "contrived by the imagination."[16]

In the 1950s, there was a striking similarity between Colville's work and that of Harris. Like Harris's paintings, Colville's possess a surreal theatricality owing to the dislocation between elements, the sense of absurdity resting below surfaces, and the quality of light that animates the subjects and establishes the dynamics of the compositions. His use of light creates tensions between the perceived naturalism of the scene and the irrational placement of elements within the illuminated space. Colville's paintings simplify

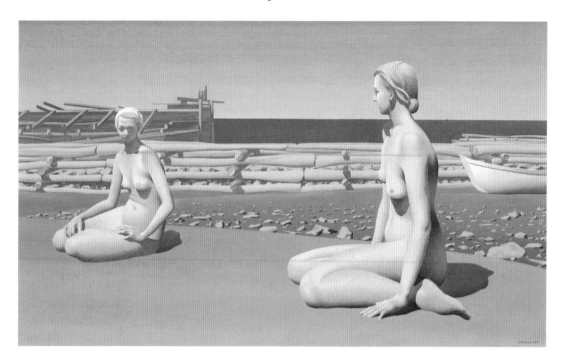

forms into generalized masses and planes, emphasizing volume and the transition from light to dark. In *Nudes on Shore*, the forms seem sculptural as they sit torpidly within the illusory space of the foreground. For all their perceived naturalism, the figures are oddly dissociated from the landscape. The contiguity of the nudes to each other and to the empty tidal basin, the wharf and beached dory set up a mysterious dialogue among the components of the composition.

The third member of the fine arts faculty from whom Mary received instruction was Ted Pulford. If Harris was the mystical romantic of the school and Colville the philosophical godfather of Atlantic Realism, Pulford was the "guru" of technique.[17] His reputation as a teacher and artist lay in his "meticulous dedication to the basics of drawing and painting." Pulford's early art training began in the 1930s with Ernest Lindner in Saskatoon, from whom he learned a technique of drawing based on close observation and imitation of natural details and on describing proportion through the relationships of parts to the whole object being drawn. Pulford also developed a proficiency in watercolour painting from Lindner. Like Harris and Colville, Pulford served in the Second World War, although not as an official war artist. After the war, he came to Mount Allison as a student of fine arts, and, upon graduating in 1949, he was immediately hired as an instructor. "I was always low man on the totem pole," recalled

Alex Colville, NUDES ON SHORE, 1950
tempera on masonite, 61.0 x 98.4 cm
Collection of The Beaverbrook Art Gallery

Pulford, and so the responsibility to teach freshman courses — the "basics" of first year — fell to him.[18] There was little chat about the philosophy of art in Pulford's classes. Although the winds of Abstract Expressionism were blowing through the art world beyond the Tantramar Marsh, Mary was not encouraged to allow the excitement to interrupt her concentration on the intricacies of ellipses or the difficulties of symmetry. Pulford's *Self-Portrait (Diploma Piece)*, which he completed as part of his own fourth year at Mount Allison, hung on the wall of the freshman drawing studio. For Mary West, it was an example of "academic excellence," setting a standard that few students ever equalled.[19]

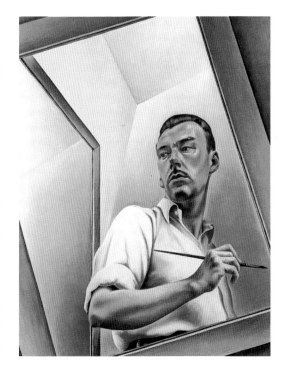

Mary was immersed in a full course load including some thirty-five hours of instruction each week. Colville taught her "The History and Appreciation of Art," "Life Drawing" and "Modelling." Pulford taught "Basic Drawing," "Design" and "Still Life Painting." (Harris did not teach freshman classes.) Out of this mix of personalities, students were given a grounding in basic principles of design and proportion, an understanding of still life and portraiture, an ability to draw based on the study of antique sculpture, and an appreciation of the history of art.

Mary was fortunate to find herself a student at an art school that was much more than the sum of its course offerings. She had entered Mount Allison at a unique moment when the mercurial blend of three well-defined artistic temperaments conspired to create an art school of intellectual depth and creative rigor. Students were not simply fed technical lessons — as important as they were at Mount Allison — they also learned from their professors the expressive range of the naturalistic mode.

Although Colville taught figure drawing, he also worked a great deal of the time in his studio at the Owens Art Gallery in the 1953-54 academic year, and Mary watched as he painted the celebrated 1954 canvas *Horse and Train*. Colville's classes were designed to

Ted Pulford, SELF-PORTRAIT (DIPLOMA PIECE), 1948
oil on canvas, 101.5 x 75.5 cm
Collection of Owens Art Gallery, Mount Allison University, Sackville

make the students become comfortable with the media and formats of drawing. He taught Mary gesture drawing, movement and balance. In marked contrast, Pulford made her look and measure with a ruler before putting a mark on the paper. His drawing class stressed the dogged academicism of working from plaster casts of antique statues using plumb lines, measuring proportions with outstretched arms, and gauging ratios with thumbs and squinted eyes.

Pulford's studios had all the attraction of a grammar course; Mary was expected to be able to make a free-hand drawing of an ellipse by Hallowe'en. After November she was taught the correct use of tone to create shadows, modulate form and mass, and indicate shadows and reflected light. The "Still Life Painting" studio focused on "the painting of static objects, with attention centred upon design, both in the arrangement and treatment of groups, and in the employment of the various techniques used in oil, watercolour and tempera painting."[20] Pulford's offerings to the uninitiated consisted of the practical study of principles and elementary theories.

The artistic requirements of Mary's BFA programme were balanced by mandatory academic courses in the history of art and English literature. Colville's art history course was more of a primer on "understanding the aesthetics of the visual arts," in which Colville guided her in appreciating how the mind of the artist is expressed through creative accomplishment. Colville also taught Mary to analyze works of art on a formal basis to understand the artistic intent behind conception and how intent was reflected in form. Although Colville's purpose was dispassionate instruction, Mary quickly realized that her professor was using his own aesthetic sensibility to interpret art history. She was learning not only about the history of art, but also about the thought process of a charismatic teacher and artist whom she esteemed greatly. Mary excelled in her studios and classes. She was "impatient" with still lifes, "better" at drawing the portrait, and found her "favourite" course to be Pulford's plaster-cast drawing class.[21]

Mary's first full-year class with Harris did not occur until 1954-55, her second year at Mount Allison.[22] She was enroled in his portrait-painting studio, which consisted of eight hours per week of the study of the head, hands and figure of live models. In these classes, Harris placed emphasis on understanding colour, texture and anatomy, on systems of measuring proportion, on characterization, and on the use of various media from oil to watercolour.

In spite of Harris's emphasis on technical proficiency extending from observation, Mary knew that he used photographs in his own work.[23] In a school that regarded the ability to draw what one saw an indispensable skill, the use of photography might have been considered heresy, but not with Harris as director. Mary came to understand that Harris used photographs as a surgeon would X-rays. She remembers particularly an incident when Harris had been asked to do an official portrait of Chief Justice J.B. McNair. When he learned that the artist would be working from photographs, McNair refused to proceed with the commission. Mary's father, who had been involved in arranging the commission, discussed the misunderstanding with Harris, who felt compelled to justify his decision to use photographs. She remembers Harris explaining to her father that it was merely a matter of practicality that he used photographs: McNair would inevitably have to sit for hours at a time and Harris would have to travel to Fredericton, frequently during inclement weather. Although Harris was being considerate and practical, Mary and her father thought that he was naive. McNair *wanted* to sit for his portrait and, by watching the process unfold, become privy to the mysteries of the creative process. In the early 1950s, Frederictonians had very few occasions to come in contact with artists, let alone watch one paint. "Whenever most people even thought about art," Mary wrote later, "[they] assumed that it was alien to the point of witchcraft." They saw only its "extremes" in Fredericton: either the "extreme bohemianism" of the artists who were associated with the UNB Art Centre, or "the amateur efforts" of the members of the various art clubs and societies of the city.[24]

In Mary West's eyes, Harris was authentic. In a city and province that saw cachet in social achievement, Harris had "presence." The son of a successful artist who was a member of the Group of Seven, he had the added imprimatur of descending from a wealthy family. However, the very qualities that gave Harris a sense of confidence in matters concerning art and his choice of technique also cast a sardonic shadow over his character when it came to the trappings of the art world. He would have seen through the polite societies of Mount Allison and Fredericton, and he would not have questioned the validity of using photographs instead of preliminary drawings as sources for his paintings.

Harris was wary of the art world. Through his father, he had become aware of its "tricks."[25] To Harris, the photograph was a forceful denial of the underlying subjectivity of abstraction that (more often than not, he believed) masked an insufficient grasp of the fundamental techniques of artistic representation. Harris considered that photo-

graphs presented facts objectively, without the distorting lens of subjectivity. Like the pencil or brush, the camera was simply a tool. He was not ashamed to admit to the use of photography in his work. Yet his derisive view of the art world came from the knowledge that many of his colleagues and peers were also surreptitiously using photographs in their work, while at the same time ridiculing him for doing the same.[26]

Harris had few friends within the art circles of Mount Allison. Shunned by his colleagues at the university, perceived as anachronistic by the fine arts students who gravitated to Colville and by those who were more interested in exploring the possibilities of Abstract Expressionism, Harris turned inward. By the mid-1950s he began to work in a mode of abstraction that reduced form to its underlying structure, the very antithesis of his portraiture.

Mary thrived in the environment of Mount Allison. As part of "the art gallery crowd," she gained some notoriety among her classmates when she challenged Alan Jarvis, director of the National Gallery of Canada, to justify statements he had made in a lecture to Mount Allison students. She took aim at his claim that Sackville and Mount Allison were "backwaters," incapable of teaching students anything about art. In an act of gentle insubordination, Mary interrupted his lecture by questioning his claim that the only reality worth discussing was one fraught with violence and angst. This was a necessary ingredient in a young artist's education and provided the correct fodder for making art. Could not "pleasant experiences" provide the same, she asked? Jarvis, in an unmistakeable put-down, told the young student, "No."[27]

Throughout Mary's second year, Ted Pulford continued to instil the fundamental principles of design and colour theory. Both he and Harris filled in for Alex Colville, who was absent most of the 1954-55 academic year because of illness. Harris tried to make the students work in abstract modes, while Pulford would send the students to the grocery store to choose elements for still-life compositions. During one of Mary's forays to the store, she met a young pre-med student, Christopher Pratt, who told her to buy a salt herring, rather than the apples and oranges she was reaching for, and to paint it as it lay on the pink butcher paper, which she did.

The friendship between Mary and Christopher continued into Mary's third year at Mount Allison. Although Christopher was not a fine arts student — he had begun as a pre-med student but by his third year had switched to a Bachelor of Arts programme — he was conscripted by Mary to help to make decorations and to paint a mural, based

on a *Brigadoon* theme, for the fall prom. In fact, Christopher became so involved in the project that he did not attend any of his classes in the fall term.

From the beginning of their relationship, Mary respected Christopher's artistic talents. To the third year fine arts student, he was truly gifted. His forthrightness and intensity were modulated by an ironic wit and an ability to spin a good yarn. The vibrant combination of talent, emotion, humour, vitality and irreverence that was Christopher Pratt attracted Mary and soon the two were inseparable friends. Although he floundered around in his undergraduate years, Mary thought that his natural abilities as an artist outshone those of her classmates taking fine arts courses. His dissatisfaction with university stemmed from a misdirection of his energies, a denial of his natural abilities as an artist. When he returned home from Mount Allison during the Christmas break in 1955, Christopher announced to his father that he had decided to be an artist. Jack Pratt let him set up a studio in the family home.

Meanwhile, Mary continued to work toward a Certificate in Fine Arts, which she received in the spring 1956. A bachelor's degree would have required a fourth year of study. However, because she would have been the only student in fourth year, Harris asked her to postpone her entrance by one year in order for her to study with Tom Forrestall, a talented fine arts student who was then only in his second year. Mary agreed to this suggestion, although it would mean delaying her own graduation. Thus, in the spring of 1956, when she was twenty-one years old, Mary moved to St. John's, Newfoundland, to work as an occupational therapist and to join Christopher, much to her parents' disapproval.

Mary and Christopher at Mount Allison University, c.1955

Chapter Three
SALMONIER

"You pretty little girl. What a place for you to be," intoned Christopher's aunt after meeting Mary.[1] Indeed, upon arriving in St. John's, Mary often thought the same thing. She found the people she met there were quite wealthy, or at least prone to ostentatous display. Thanks to her United Church upbringing, Mary found this behaviour to be mildly offensive, although also somewhat exotic. She spent her first year in St. John's experiencing its culture and manners from the outside, as if through a celluloid screen, watching and being amused at the terrible denominational rivalries among religions, taken aback by attitudes to politics, but nonetheless marvelling at the willingness to throw oneself into public service.

"Christopher was totally committed to success. I thought it was peculiar and fascinating to resist," she wrote in her journal in 1977.[2] He introduced Mary to his "country" — Newfoundland — with a fierce pride that she could not understand at first. Her upbringing in New Brunswick made her suspicious of a nationalism that found its identity in regionalism. The harsh, abrupt opinions of Newfoundlanders astonished her sense of decorum, which frowned upon interruptions and gracefully tolerated contrary opinions. Christopher, "serious about everything he saw," talked about Newfoundland with a passion and conviction that eventually rubbed off on Mary. "[I had] lived in a very simple way," she maintained. "Fredericton was a garden of a city, and my parent's garden was wide enough and pleasant enough to hold me." But with Christopher, Mary was shown "little lichens and all the plants in what seemed to be, on the surface, just plain Newfoundland bog."[3]

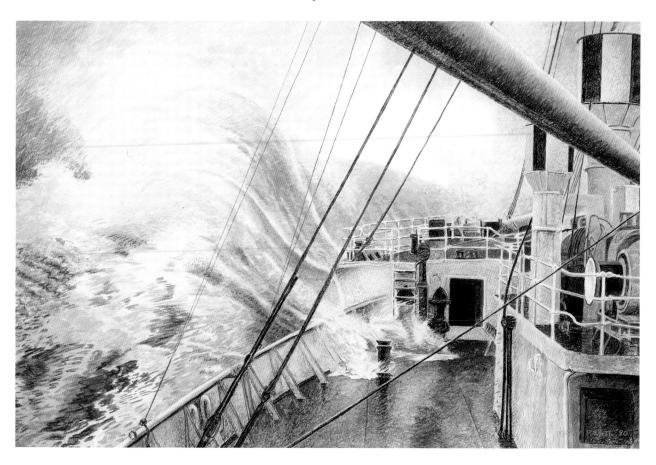

TO GLASGOW, 1990
watercolour and pastel on paper, 103.5 x 151.0 cm
Private collection, New Brunswick

Rather than return to Mount Allison to finish her final year of the BFA programme in 1957, Mary married Christopher in September. They immediately left for Scotland, where they both intended to study at the Glasgow School of Art. "I could have married a more ordinary person," Mary commented in 1984, "someone who was going to be a lawyer . . . Christopher was a challenge. He wasn't going to be ordinary."[4] Leaving her familiar world, Mary Pratt turned her back on the manners and security of her youth, where her sense of place and quiet confidence were products as much of her upbringing and education as they were of the society itself. In New Brunswick, Mary had known that the parts of one's life could be as neatly compartmentalized as the egg-carton pews of Wilmot Church. Her sense of order was reinforced by her studies at Mount Allison, where she learned that talent and ability flowed from discipline and training. These set you apart. Nuance and subtlety in art and in life were not qualities of unrestrained subjectivity, but the products of an intimate familiarity with conventions. Mary's marriage to Christopher would test the truth of this maxim. Looking back, Mary also realized that she never would have become an artist had she married "an ordinary person."[5] In an ironic way, Alan Jarvis's haughty put-down in a Sackville lecture theatre would prove true.

Mary Pratt believed that, if she "married fairly young, had children, learned how to cook and dust and so on," life would unfold for her in "a rather easy way," and that she "would have something to paint."[6] Her expectations, it would seem, matched those of her peers whose aspirations, as women, were defined by the ambitions of their husbands and the needs of their families. But Pratt also knew that her destiny was to be an artist. Her world would be defined not merely by domestic activities, but also by artistic creation. She was an artist and she had married an artist. Art would occupy the centre of her family life and have the same presence that politics had in her mother's life and business had in Mrs. Pratt's life.

After arriving in Scotland, Mary learned that she was pregnant, and so Christopher alone attended the Glasgow School of Art. It provided him with the opportunity to learn the discipline necessary to his profession in a manner similar to Mary's experience at Mount Allison. The Pratts spent one year in Glasgow, he immersed in the rigorous programme of the art school, she content to paint small oil panels in their flat and visit the museums of the city or the Botanic Garden. Ten months after their arrival, they returned to Newfoundland, where their first son, John, was born in July 1958. After John's birth, Christopher decided to leave St. John's once again, and he and Mary

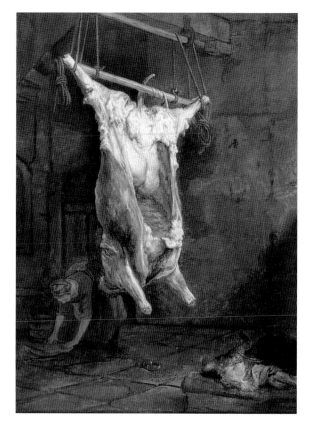

returned to Glasgow with their young son. During her second year in Scotland, Mary visited the Glasgow Art Gallery and Museum and saw Rembrandt's *The Carcass of an Ox* as well as the rest of the permanent collection. However, her two years in Glasgow were years of modest expectations and artistic output. Seeing to Christopher's needs and looking after their young child structured her days and ordered her life.

The experience of studying art at the Glasgow School of Art gave Christopher's education a focus. The Glasgow School taught art as a professional discipline no different from medicine, engineering or the law. Students were taught the absolute necessity of practice, exercise and repetition. Talent was appreciated for what it was: a predisposition to direct one's energies to work. Its unbending measurement of quality provided Christopher with a rational armature upon which he could construct an artistic practice and eventually shape a profession.

After Christopher had completed two years of study in Glasgow, the Pratts returned to Canada and to Mount Allison University. Both Christopher and Mary enroled in fine arts in the 1959-60 academic year — Mary as a senior in fourth year, Christopher as a junior in third year. Harris, Colville and Pulford were still on the faculty, but in the three years that Mary Pratt had been absent from the university, its programme had been modified to allow senior students to study in an unstructured environment. Mary discovered that she could do anything she liked within the limits of figure composition, mural painting, landscape, graphics and one elective, which she filled with a course on the twentieth-century novel taught by Dr. G.H. Thomson. Shortly after beginning her fourth year, Pratt discovered that she was again pregnant. Fortunately, the

Rembrandt, THE CARCASS OF AN OX, late 1630s
oil on wood, 73.3 x 51.7 cm
Glasgow Museums, Kelvingrove

loose structure of her academic course allowed her to extend her final year over two years so that she could balance raising her two children, John and Anne, with studying toward her degree. This arrangement also meant that she and Christopher would graduate together in the spring of 1961 with Bachelor of Fine Arts degrees.

In the fall of 1959, at the same time that the Pratts returned to New Brunswick, Lord Beaverbrook opened an art gallery in Fredericton and endowed it with a permanent collection of original works of art. Although primarily a collection of British art from the eighteenth century through the Victorian period to the twentieth century, it also contained a representative survey of Canadian paintings and drawings, both historical and modern. The presence of the Beaverbrook Art Gallery in New Brunswick gave Pratt the opportunity to study original works of art from its permanent collection, which included important paintings by Lucian Freud, Walter Sickert, Stanley Spencer, Augustus John, Graham Sutherland, Thomas Gainsborough, J.M.W. Turner and John Constable. Prior to the opening of the gallery, there were few opportunities on the east coast of Canada to see art of this calibre in one place. Understanding the practical importance of the institution's collections, Pratt visited the gallery shortly after it opened to study the paintings by Freud and Sickert, whose painting *H.M. King Edward VIII* drew her attention because of its obvious use of photographs as sources for the image.

During the Pratts' final year at Mount Allison, Christopher's career began to take shape. His serigraph *Boat in Sand* was purchased by the National Gallery of Canada, and, at the end of the term, he accepted the position of director at the Art Gallery at Memorial University of Newfoundland. Although Mary also accepted a position to teach at Memorial University upon their return to St. John's, she felt that her ambitions as an artist were being subsumed by her husband's initial successes. Seeking counsel from Harris, Pratt was given a brutal tonic; in her family, "there could be 'only one artist and that artist is Christopher,'" said Harris.[7] In retrospect, Pratt thinks that Harris was perhaps trying to save her from the strains of a difficult marriage and the awkward clefts of resentment and professional jealousy. Mary Pratt heard the advice but did not allow herself to cower into retiring. Instead, she "took hold of her life" and chose to continue painting, arranging her responsibilities as a parent around her needs as an artist.[8]

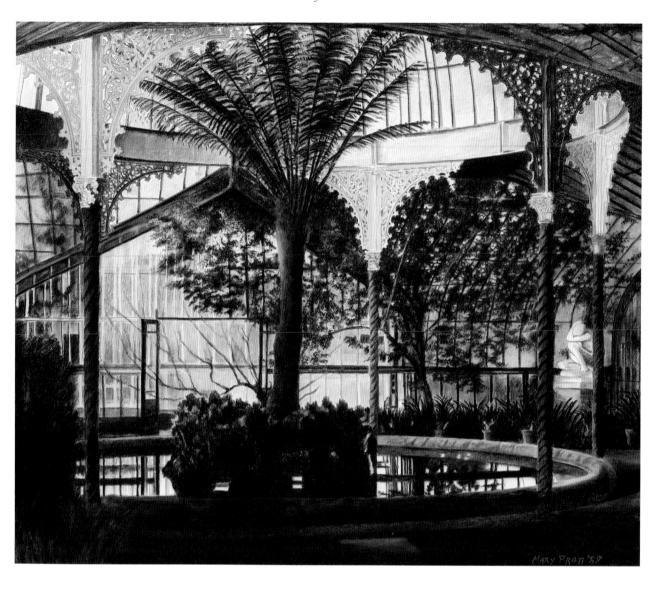

BOTANIC GARDENS, 1989
watercolour and pastel on paper, 101.6 x 116.8 cm
Collection of BC Gas Utility Ltd.

The transition for both Mary and Christopher from New Brunswick to Newfoundland was difficult. Christopher's position as director of the Art Gallery was unfulfilling. In 1963 he decided to resign because of ill health aggravated by an abiding dislike of teaching and administration. The burden fell on Mary to look after her husband and to care for their growing young family. A third child, Barby, was born in 1963. Leaving St. John's, the Pratts settled in Salmonier, a small outport community an hour southwest of St. John's on the Salmonier River. Its isolation and privation contributed to an overwhelming sense of cultural dislocation and alienation for Mary. Although Christopher required attention to allay health problems brought on by stress and a lack of confidence in his artistic abilities, she could not stop thinking about her own art. As Christopher's career began to coalesce and as he began to receive greater recognition as an artist in Canada, Mary provided him with emotional and moral support, encouraging her husband when he had few role models among practising artists.[9]

After moving to Salmonier, Mary Pratt painted as often as time and her young family would allow. A fourth child, Ned, was born in 1964. Art provided purpose and a sense of controlled order to her life. "The impression most people have is that Mary put her career on the shelf to look after the children. That is just not true," Christopher commented in 1976.[10] Mary was developing skills and techniques she had learned at Mount Allison, not the least of which was the attitude that Harris and Colville brought to their art: that it could provide a rational structure to govern the comportment of one's life. Art was a means of taking control. Technical ability was a measurement of the degree to which one could stave off the ungovernable forces that threatened to unbalance the fragile harmonies of one's life.

The earliest work which Pratt created in Salmonier was painted in what she refers to as an "impressionist" style that allowed her to capture the unique qualities of light that bathed the subjects she was painting.[11] Working on small, portable wooden panels, Pratt was able to set up her easel around the house or garden and paint views in front of her — subjects such as the surrounding landscape, her garden, the laundry on the line, flowers. Her personal style depended on loose, free brushwork that permitted her to paint rapidly her experience of the landscape.

Nonetheless, Mary's own confidence in her artistic abilities began to erode. The isolation of Salmonier, deep in rural Newfoundland, dramatically contrasted with the relatively urban life she had known in Fredericton and resulted in a severe sense of

emotional and cultural loss. Christopher's single-minded determination to build his career inevitably swamped her own ego.[12] Knowing that she had put herself in this situation only increased her gnawing sense of frustration and her feelings of alienation and malaise. The world just outside her windows in Salmonier might have been a "pretty acre of a garden with rhododendrons," but her emotional landscape had lost the few signposts that had defined her self-esteem. By the mid-1960s, Mary did not see the garden when she looked out the livingroom windows; she saw the chaos that lay beyond it in the Newfoundland tundra.

Near the end of her first winter in Salmonier, Pratt was experiencing depression and began to read what she described as "an intense novel about twins who sort of took each other's identity." "The children were asleep one afternoon, all of them, and these twins began to talk to me in my head. And I began to talk back to them. And this wasn't some kind of passive thing that was happening. I couldn't make them stop." The voices kept "gibing" her, telling her that she should be doing other things in her life. They were "nattering" at her, calling her "foolish," to such an extent that Pratt woke the children and talked to them in the hope that the voices would stop taunting her. Realizing that she might be beginning to lose control, Pratt turned to her painting more seriously than she had. She also began to write poetry, thinking that art and poetry were the only means she had to take hold of her life and give her emotional landscape equilibrium.[13]

In the midst of this period of emotional turmoil, the Pratts' Salmonier home became, as if by accident, a station on a national cultural pilgrims' road. It had always been a drop-in place for Christopher's parents, brother, relatives and friends. But, by the mid-1960s, when in Newfoundland, writers, filmmakers, artists, intellectuals and cultural mandarins also called in on the Pratts. Mary and Christopher found themselves hosts to hangers-on — "the intense fringe of hippiedom."[14] Discussions ranged widely among the visitors to the Pratt household, but if there was a common element in the debates, it was provincial politics and criticism of the Smallwood government. Christopher Pratt was an anti-Confederate. He, like many of his contemporaries, believed that Newfoundland's entry into Confederation had precipitated the loss of the province's distinct identity and its self-reliance. Confederation had forced Newfoundland to surrender trade routes, treaties and markets, placing it in a North American rather than a mid-Atlantic trading context. Christopher frequently derided the relocation of remote outport settlements as well as the social policy of the provincial

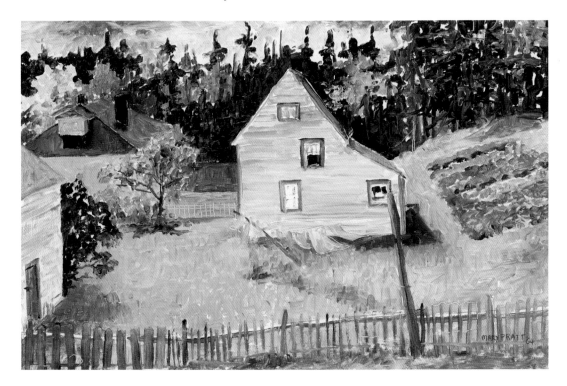

government, which was founded on the assumption that, in the long term, dependency would benefit Newfoundlanders. Many of Christopher Pratt's paintings and prints at this time depicted rural outport landscapes punctuated by clapboard buildings and were intended to be veiled criticisms of this policy.

Unlike Christopher, Mary Pratt was "from away." She felt that she was an intruder in such discussions and that "she couldn't possibly understand what was happening" to the social fabric of Newfoundland.[15] She considered herself much too rooted in New Brunswick at the time to comment publicly, even though privately she would join her husband in critiques of his work-in-progress. Spreading his work on the dining-room table, Mary and Christopher would debate how a composition should be changed and, in Mary's opinion, increasingly "formalized" — transformed — into a spare, condensed and characteristically cool image containing few explicitly expressive devices. Mary believed that Christopher's nature was best manifested in rigid, controlled interpretations of Newfoundland subjects, and she worked hand-in-hand with him as his images became art.[16]

At this time, Mary found it difficult to paint from the Newfoundland landscape. To do so would be disingenuous since she could not help but put a New Brunswick veneer

OLD HOUSE BY RYANS, 1964
oil on panel, 25.4 x 38.1 cm
Private collection

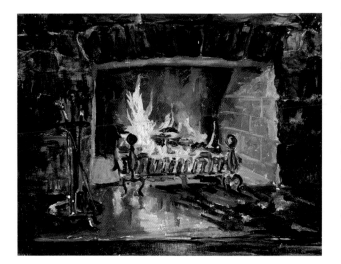

on what she saw. Although Pratt considered herself to be a regionalist, her brand was more egocentric than geocentric. "You must choose subjects you're born with and understand them instinctively," she commented.[17] Art not only expressed her experience of Salmonier ("This was my life"); it also ordered her existence.

Her "impressionist" style, with its innately immediate quality, was adaptable to instantaneous description. Although crudely painted, *Old House By Ryan's*, completed in 1964, is an example of Pratt's treatment of a domestic subject in which the immediacy of the style enlivens the surface of the painting. Its brushwork is random; small daubs of paint appear to be placed haphazardly on the surface of the panel to give a sense of movement and tension. *Fireplace at Salmonier* foreshadows Pratt's later interest in describing the intense light of fire. In her many still lifes of this time, Pratt attempted to emulate Goodridge Roberts's approach to still-life painting by using the genre to study formal problems associated with colour, light, line and space. In these small "impressionist" paintings, Pratt struggled to come to terms with the subject, her media and her direct style. Her brushstrokes do not consistently follow the contours of the elements of the still life, and the effect, although giving the sense of an immediate impression of the scene, appears forced, arbitrary and a bit rushed. *Traditional Still Life With Russet Apples*, a larger painting than her panels completed in 1966, announces a new direction for Pratt, in which she turns away from emphasizing style to concentrating on composition and describing form. In this painting, Pratt depicts the volume and mass of the apples and the irregular topography of the tablecloth against a muted palette of whites, ochres and browns in which the red apples appear to float.

By 1966, as the painting *The Back Porch* demonstrates, Pratt understood the limitations of her medium and had learned the lessons that Goodridge Roberts's art could give. The painting is a gently evocative formal study of a still life on a chair near the back door of her Salmonier home. She establishes spatial relationships by modulating a grey field indicating space receding into the background. The emphasis is placed on the

FIREPLACE AT SALMONIER, 1966
oil on panel, 24.1 x 30.5 cm
Private collection

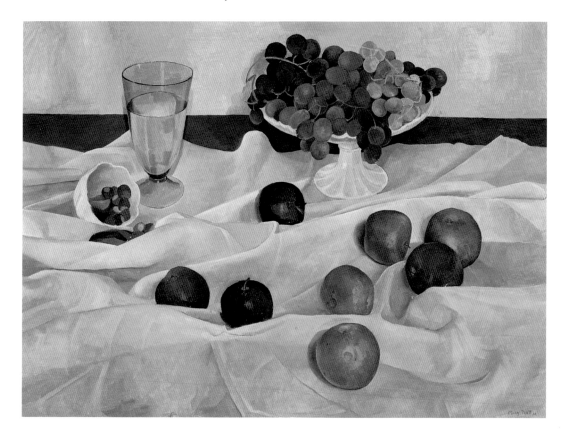

formal properties of composition and the placement of the still life in a convincing space within the picture plane. The composition itself is elegantly balanced by the rhythms of forms and shapes and by the subtle punctuations of colour set down in a controlled manner, much less randomly than her "impressionist" pieces. There is an underlying mathematical order in the composition. Although Pratt was still experimenting with form and composition through the still-life exercise, the mood she conveys through the nuances of light falling over the forms sets her apart from Roberts and his emphasis on form alone.

Sixty of Pratt's paintings, completed between 1956 and 1966, were exhibited at the Art Gallery of Memorial University in March 1967. The exhibition gave her the opportunity to review her progress in what had been a decade of creative and emotional transitions. Not surprisingly, St. John's art critic Rae Perlin chose to highlight the fact that the paintings were completed while Pratt was raising a young family, and that the subjects were drawn from her immediate surroundings. In retrospect, Perlin's comments seem prophetic. They would be echoed and repeated as mantras by a generation

TRADITIONAL STILL LIFE WITH RUSSET APPLES, 1966
oil on canvas, 68.6 x 91.4 cm
Private collection

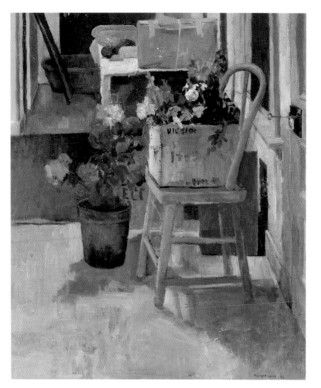

of her critics to such an extent that Pratt's world became this myth: Mary Pratt had to "grasp time to paint," while looking after her home, her husband and four small children.[18] To Pratt, however, the exhibition represented a "taking hold" of her life.[19]

Not long after the exhibition closed, two intense experiences prompted Pratt to reassess her approach to subject matter, both of which conspired to transform her personal style from "impressionism" to photo-realism. Pratt was dissatisfied with what she referred to as her "ugly and messy" handling of paint. The impasto surfaces of her small panels appeared to her to be incomplete, uncontrolled and unrealized conceptions of form and light.[20] She remembered that she preferred the printed photographs on the large calendars that her grandmother MacMurray gave her as a child, showing "chickens, ducks, little boys and girls holding rabbits." Years later in Salmonier she recalled that "one night as I was putting my foot in the bath water, all of a sudden the scene in front of MacMurray's Bookstore [from one of these calendars] came back to me."[21] This experience led her to consider using photographs as subjects and to attempt to adapt her personal style to imitate not only a photographic mode of description, but also the smooth quality of their surfaces, by eliminating all traces of brushstrokes. The "ugly and messy" qualities of her impressionist style represented an outward expression of a lack of control. As went her art, so went her life; the task at hand was to remove signs of expressiveness, to restrain subjective style by what could be seen as the stylelessness of the photographic image.

The second experience also involved the influence of her grandmother, Edna MacMurray. One afternoon, while Pratt and her children were putting together a puzzle on a glass table in the livingroom of their Salmonier home, she looked out the window across the Salmonier River and thought she heard her grandmother's voice

THE BACK PORCH, 1966
oil on canvas board, 50.8 x 40.6 cm
Collection of Memorial University of Newfoundland, St. John's

telling her that the important quality of a painting "is the light, it's the light, you know. That's what's important, you know."[22] The startling directness of the voice helped Mary to overcome an impasse in her painting that extended from her dissatisfaction with the brushstrokes of her "impressionist" paintings. The voice focused Mary's mind, causing her to think less about paint application and more about portraying light. Both of these experiences were

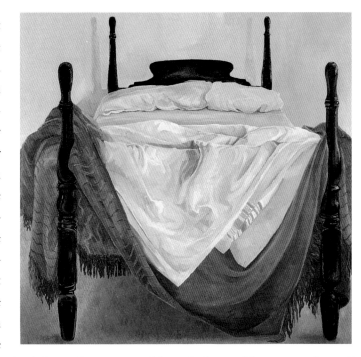

moments of clarity for Pratt, which hereafter governed her choice and interpretation of subjects and her handling of paint.

One of the first examples of this shift in perception is a painting that Pratt began in the fall of 1967. While doing the housework one morning, she went into her bedroom and saw the morning sun shining on an unmade bed. As Pratt describes the scene, "the bed was all tumbled together . . . and was reflecting in the shiny linoleum. The blankets had that boiled-wool look. The bedspread was dyed red, and the flannelette blanket was spread over the bed."[23] Pratt was deeply affected by the scene, a vision of light, colour, emotion and associations, to such a degree that she saw the experience as "erotic." Her response to it was sexual; her impulse was to paint it immediately. She set up her easel in the bedroom and tried to paint the scene before the light changed. In the process, she was frustrated by the fugitive quality of the light, which was continually changing the relationships of light and shadow, tint and tone while she worked to put them down in paint. The light was not "standing still long enough for me to catch it," she said later.[24] Its movement across the room altered the image before her, and her reaction to it changed; it was maddeningly difficult to control her interpretation of the scene as she painted directly from it. The result of this experience is *The Bed*, completed early in 1968, a pivotal painting in her career. An essay in creams and ochres in an uncharacter-

THE BED, 1968
oil on canvas, 91.4 x 91.4 cm
Private collection

53

istically large format, *The Bed* unfortunately conveys little information about the quality of light bathing the scene that induced Pratt's vision. She now refers to *The Bed* as "a painting of a friend. It was about what I saw, not about painting."[25]

Following the epiphany that led to *The Bed*, Pratt decided that painting "had to speak to her" with a similar intensity and that the subject had to embody the same sensual quality that she experienced during the moment of intense perception. "It had to punch you in the gut, give you a high," she said, referring to her urge to engage viewers on a physical as well as on emotional and intellectual levels. But capturing the immediacy of the scene and the elusive, ever-changing light proved a greater challenge for Pratt than she first assumed.

In time, Christopher provided a solution. Pratt and her family were having dinner one evening when the view of the table in front of her gave rise to an intense urge to paint the scene on the spot. Christopher, however, insisted on photographing the scene in 35-mm slide format in order to capture the particularity of its light. As she was drawing the view, he photographed the table. When Mary saw the slides a few weeks later, she realized that the amount of information available from them allowed her many more possibilities in interpreting the subject.[26]

Chapter Four
NEW REALISM

"I was quite amazed at the sight of it. It was a physical reaction," Mary Pratt recalls of seeing the slide that Christopher had taken of the supper table.[1] Although she was aware that artists made use of photographs as sources for images, particularly Lawren P. Harris, she declared, "I didn't know people worked from slides. I didn't know anybody else who did that." Salmonier, by the simple virtue of its isolation, made it relatively easy to be insulated from developments in the visual arts, either as a matter of fact or as a matter of choice. For Pratt, it was a bit of both. "We had stopped our subscriptions to art magazines."[2] Without immediate access to journals and magazines, Pratt worked in a self-imposed vacuum that proved to be beneficial. Working in isolation allowed her to reconcile her working methods with her use of photographs and not to feel guilty about relying on photographic images to supply information about subject matter.

Since her earliest art lessons in Fredericton with John Todd, Pratt had seen the various uses of photographic images in art. Todd encouraged her to keep a file of photographs to stimulate ideas about subject, composition, design or graphic presentation. At Mount Allison, Harris used photographs as sources of information when painting formal portraits and when rendering naturalistic details in paintings. Pratt found these lessons to be invaluable in 1965, when she created a series of naturalistic drawings of snipes for an ornithological publication.[3] She had also used a photograph to guide her as she painted a commissioned portrait of a New Brunswick judge in the 1960s. Indeed, she was also able to see how Christopher used slides and photographs as sources and references in his own work.

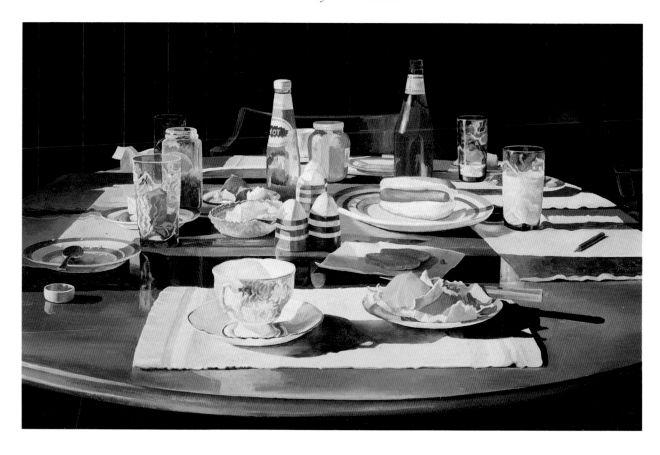

SUPPER TABLE, 1969
oil on canvas, 61.0 x 91.4 cm
Collection of the artist

After Christopher had given her the colour slide of the supper table and she saw "exactly what she wanted," Pratt set aside her preliminary drawings of the scene and began working on the painting *Supper Table*. She projected the image from the slide onto a gessoed canvas and drew what she referred to as a "map" of the table.[4] Tones and colours were then laid in by brush and thin oil paint to establish the relationships between objects and their place within the illusory space behind the picture plane. At this point, the slide became less important in her process of painting. Not attempting to match exactly the colours to those projected from the slide, she would "almost make the colour up" as she went along, using slight variations of the tones and tints that she saw in the slide.[5] A cool tone from a blue or green established the relative values of all other colours. In the final painting, Pratt emphasized the play of light on the surface of things and its reflections in those surfaces. Light rakes the surface of the table, entering the composition from the left side and creating hard contrasts between light and dark. A strong contour line clearly delineates the boundaries of objects, which in turn logically places them within the space of the composition. The overall composition is open in the foreground, placing viewers at the supper table. Within the composition, Pratt also sets up rhythms between shapes and forms — the salt and pepper shakers, the glasses and saucers, and the lines of decoration on the plates. The elegance of the composition and these linear rhythms make a convincing essay about the spatial relationships behind the picture plane. Within this interplay of light, form, line and space, no people are present. The random disorder suggests that the family has just been excused and the nightly ritual of cleaning up is about to begin.

Pratt's professional career began with *Supper Table*. It set her artistic course while severing any abiding links with her "impressionist" paintings and student work. *Supper Table* announced forcefully her mode of representation — photo-realism — and the fact that she would choose subject matter drawn from the immediate environment of her house in Salmonier. In retrospect, the sense of isolation and emotional disequilibrium

35-mm slide used as the source for SUPPER TABLE

HERRING ON SALT BAG, 1969
oil on panel, 76.2 x 53.3 cm
Private collection, New Brunswick

that she experienced in Salmonier shaped her as an artist. The physical isolation allowed her to find her voice by experimenting with styles, uninfluenced by ideas emanating from centres of the artistic mainstream, whether in New York or in Toronto. The rootlessness she experienced in Salmonier forced her to realize that art structured her life, that without it she was adrift in a world of visions and voices which gave insight but eroded her self-esteem. "I don't think I'd have been a painter at all if I hadn't come out here," she said in an interview in 1989. "This is an abrupt, dramatic light and dark kind of society. You're rich, you're poor, you're wildly happy, or you're depressed."[6] Even though as a young girl in Fredericton she had guessed that she "would be spoken to," little would she have believed that in her adult life in Salmonier, the voice of her muse would be her grandmother, Edna MacMurray, telling her prophetically, "it's the light that's important."

By the middle of 1968, Pratt realized that, if she were to salvage any kind of career, she would need help with the day-to-day running of the household. That summer, Mary and Christopher hired Donna Meaney, from nearby Mt. Carmel, to take on many of the domestic responsibilities, including care of the children, thus allowing Mary uninterrupted time in her studio. Donna would also model for Christopher. She worked for the Pratts daily during the summer and came to live with them that fall. Almost immediately she began to reorganize the routine of the house and assume a central place in the domestic order. Donna understood her role both as model and as muse to Christopher and helped him to overcome frequent creative blocks and periods of self-doubt. This caused tensions between husband and wife and hurt feelings in Mary. Mary saw that, with Donna as a model, Christopher's art benefitted, and that, through Donna, Christopher became a better artist. The relationship between Christopher and Donna forced Mary and Christopher to reconfigure their marriage and negotiate a relationship with one another that allowed a place for Donna as Christopher's creative anima. Despite the changes, Donna's presence in the household did give Mary time to paint and gave both artists room for their art to develop.

In 1969, an extraordinarily prolific year for Pratt, she used photographic sources in all of her paintings. In *Herring on Salt Bag*, Pratt was drawn to the simple balance of the image as well as its obvious poster-like — or calendar-like — composition. But beyond its formalism, *Herring on Salt Bag* is also a celebration of the annual return of the migratory herring to Placentia Bay, which had been depleted of its fish stocks because of phosphorous pollution.

CAPELIN, 1969
oil on panel, 76.5 x 101.6 cm
Collection of Memorial University of Newfoundland, St. John's

BAKED APPLES ON TINFOIL, 1969
oil on canvas, 40.6 x 61.0 cm
Collection of the New Brunswick Museum, Saint John

So, too, *Capelin* celebrates the annual inshore migration of the capelin stocks. Both paintings are about abundance; in *Capelin* Pratt finds joy in plenitude, while the meagre catch portrayed in *Herring on Salt Bag* draws attention to plenitude through its absence. *Capelin* is essentially a disorienting collage of harvested fish arranged to emphasize bounty. Yet, from the apparently flattened space of dead fish seen from above, Pratt transforms the mundane subject into an essay about the shallow space within the painting. The sinuous bodies of the fish overlap and entwine, resulting in a complex visual rhythm. Pratt also conveys an unusual sense of depth by placing an area of deeply saturated dark tone near the centre of the composition. This tonal void acts like a pictorial vacuum that draws the eye through the space and into infinity.

Pratt also set herself the formal problem of exploring the subject within the confines of a shallow space in *Baked Apples on Tinfoil*. In this painting, her handling of the apples draws attention to the elegant formality of the composition. In this instance, the tray that holds the baked apples limits the space receding from the picture plane; the apples appear to be caught within the narrow confines of the space within the painting. Yet, making use of the device of the void once again, she militates against this restriction of space. The holes at the cores of the apples draw the gaze into a deep, seemingly limitless visual space at the centre of the fruits.

Pratt's interpretation of the forms of the baked apples borders on the anthropomorphic. Each apple has been given a distinct character, owing both to the slight differences of local colour and to the varied orientations of the dark cores. Her handling of surface textures and the skins of the fruit creates allusive, mammarian shapes. The light bathing the forms emphasizes texture; the play of indirect light off the surfaces of the foil, apple skins and pulp creates a palpable sense of warmth. Pratt's interpretation of the subject is not simply a formal analysis of shapes and light using the domestic subject as a foundation. It could also be a study of fertility, the transubstantiation of spent fruit. The balance of the composition and the objectivity of the point of view are cancelled by the allusive meanings of the subject carried beyond what is obvious at a first glance; there is complexity in its subtle balance and simple, lyrical harmonies.

The sense of disorientation, owing to Pratt's use of the viewpoint from above in paintings such as *Capelin*, *Herring on Salt Bag* and *Baked Apples on Tinfoil*, is also present in her painting *Eviscerated Chickens*, which she began in 1970. In this work, Pratt luxuriates in describing the flesh of the chickens, its textures, folds and ripples. Her depic-

tion of the shallow space of the picture plane is more complex than in *Baked Apples on Tinfoil.* Pratt emphasizes the quality of light bathing the still life and the reflected light playing off the variety of surface textures. She suppresses all evidence of brushstrokes to heighten a detached, non-subjective view of

the still life. In places, Pratt delineates discrete objects, unifying them in a cohesively organized composition. The integration of the elements of the still life is brought about as a movement from dark to light, and as a progression through the various textures of cardboard, paper and flesh. In other places, Pratt's handling of form seems to draw out its abstract qualities. The carcasses seem to lose their definition within colour fields. Indeed, the textures and light emanating off them are so intensely seen by Pratt that the overall shapes of the chickens dissolve in amorphous patterns and tones. Based on photographic slides, *Eviscerated Chickens* is an exploration of light falling across flayed carcasses in which Pratt portrays a commonplace, if essentially gruesome, scene. In her hands, the flesh of the fowl becomes all flesh.

Although *Eviscerated Chickens* is a remarkable painting, Pratt suddenly ceased working on it because she was not fully comfortable with her reliance on the photographic image to structure her working process and personal style. She felt that her art was "corrupt," not much better than "copying."[7] And so, from September to December of 1970, she turned her back on painting and took sewing classes instead. If not for the intercession of her husband and family over the Christmas season, she might never have returned to her art. As a gift that Christmas, Christopher presented her with two slides — one of the eviscerated chickens and another of a landscape — with a note imploring her to paint from these slides, or else, "I will be visiting you at the Waterford [hospital] every weekend with flowers." The tactic worked. Pratt returned to painting in the new year and completed *Eviscerated Chickens*.

When Pratt ceased painting in a time of creative doubt about the validity of using photographs, she was unaware of the debates surrounding the rise of New Realism in the United States and Canada. The cancellation of her subscriptions to art journals and

35-mm slide used as source for EVISCERATED CHICKENS

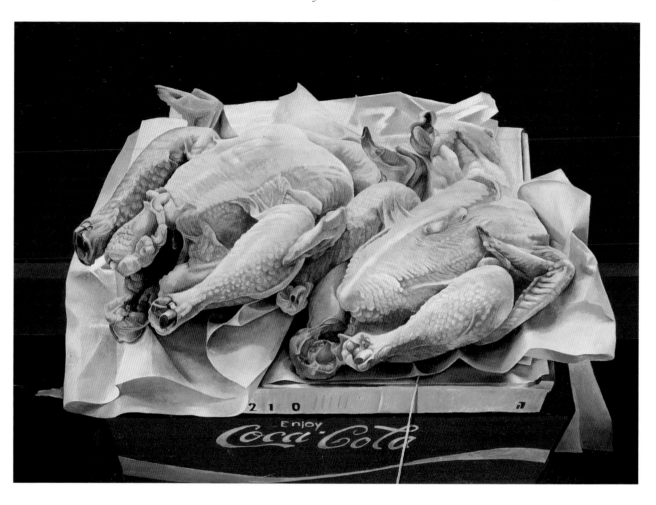

EVISCERATED CHICKENS, 1971
oil on panel, 45.7 x 62.2 cm
Collection of Memorial University of Newfoundland, St. John's

her detachment from critical discussions added an extra degree of insulation to her situation in Salmonier. Had she been able to keep abreast of the growing pluralism that was eroding modernism's authoritative voice, she would have discovered that her choice of style and her intentions were consistent with those of many New Realists: artists in Canada, the United States and Europe who were working in a mode of representation that used photographs as sources for imagery, many of whom were making paintings about "how the camera sees."[8] Despite her ignorance about New Realism, Pratt was creating her work in the midst of an international movement that sought to re-evaluate Realism and its contemporary stylistic manifestations. Although she might have been unaware of the specific issues and debates arising from this movement, her work was part of the phenomenon.

Pratt's formative years at Mount Allison inculcated in her a respect for the technical complexities of realism and its myriad stylistic forms, primarily those surrounding the work of both Colville and Harris and, to a limited extent, that of Pulford. Through the work and teachings of Colville, Pratt was given privileged access to the theory and practice of a Canadian magic realist who was then gaining international attention. Her artistic roots at Mount Allison set the path of her future development as an artist. By 1970 she was exploring but one part of the stylistic spectrum of the contemporary realist movement — imitating in paint the photographic image.

This impulse ran counter to the dominant voice of abstraction. The New Realists — among them Philip Pearlstein, Chuck Close, Robert Bechtle, Richard Estes, Malcolm Morley, Duane Hanson, Pratt herself and her Canadian contemporaries Jack Chambers and Robert Young — asserted that a purely visual perception of the world was a valid basis upon which to compose a work of art.[9] As the New Realists gained critical notice in the late 1960s, their work was characterized both as the very antithesis of abstraction because of its recognizable subject matter, and also as its close cousin because of its commentary upon formal properties and processes of painting. Not surprisingly, in light of the modernist trend to reduce the level of meaning in a work of visual art to analysing the structure and nature of painting itself — its innate flatness, for example — realist painting was viewed as regressive because of its ability to suggest meaning beyond self-reference. According to the canons of abstraction, the work of art was sufficient meaning unto itself; to the New Realists and to Mary Pratt, however, a work of art gave witness to a perception of the world.

The primary issue surrounding New Realism was recording perceptual data rather than exploring the structural properties of painting. New Realist paintings and sculptures made frequent use of the characteristics of the photographic image — the arbitrary nature of cropping, the mediation of the lens and the effects of blurring, the close-up and narrow depth of field, disproportionately large scale, and evenness in point of view — to suggest an unedited, objective gaze. Yet the vocabulary of abstract painting — the largeness of scale, the tension between the innate flatness of the pictorial surface and the illusory spatial depth behind the picture plane — played a central role in the formulation of the stylistic characteristics of New Realism.

The proponents of New Realism declared that objects should establish themselves "first of all by their presence," and this "presence" should prevail over explanatory theories that interpreted objects.[10] New Realists affirmed that a subject is worth looking at simply because it exists, and that "within the bounds of comment there is no comment."[11] Explanations were considered to be gratuitous when confronted by the reality of things.[12] New Realist artists such as Estes, Hanson and Close, for example, destroyed the myth of hidden dimensions of meaning beyond that of the inhabited world. Commentary or interpretation suggested by expressive or stylistic devices was suppressed in favour of the cool visual vocabulary of the photograph. At the core of their work was an attempt to explore as completely as possible the relationship between the work of art and the reality of the objectively perceived external world. New Realists took aim at the assumption that the existence of a recognizable subject in painting implied a narrative or symbolic meaning. They contended that objects simply exist, that art should express nothing beyond itself. Stripping objects of all meaning beyond their presence, however mundane, the New Realists suggested that their work was symbolic of nothing.[13]

The most important legacy of the New Realists was the legitimization of the use of photography for source images in painting and sculpture. Photographic subject matter, for example, was seen as a means for exploring visual perception. In 1970, Mary Pratt need not have been concerned about referring to photographs and slides in her own work. Like Pratt, the New Realists were consciously imitating the vocabulary of the photographic image. Like them, Pratt chose her subjects because of their banality. And just as the New Realists described objects in a cool, neutral manner approaching reportage, so Pratt painted without interpretive glosses such as explicit brushstrokes.

By precisely rendering subject matter as set down in the photographic image, Pratt was easily able to distance herself from the subject's emotional content. She described the mundane but did not tell viewers how to feel toward it, unlike many contemporary New Realists who found in the expression of banality a fertile field for ironic comment. Pratt's work is devoid of irony. For her, translating the photograph exactly, including its palette dictated by the Kodachrome spectrum, its out-of-focus areas and its variable depth of field, was a discipline within which she could explore her limits as a painter. Like the New Realists, Pratt communicated the camera's gaze, but by translating it slowly and laboriously into her art, she showed that she was not satisfied with the camera's product.

Without realizing it, Pratt went beyond the limits of New Realist painting, largely because of her motivation to use a camera to photograph a subject. To Pratt, a source photograph was more than a record of a "mundane life," even though the trappings of domesticity *were* her subjects; her paintings were about much more than "how the camera sees." She arrested the situation to capture the momentary quality of light as it fell on objects within her gaze; this necessity gave rise to the impulse to accept a camera in the first place. The camera permitted her to record an event that sparked an intense perceptual experience, one of clarity of vision and thought, which also gave her a sexual charge. The slide she took froze the quality of light that surrounded the experience. In short, Pratt wanted to describe the "presence" of a scene through its light and objects. To Pratt, the colour slide served as a convenient record yielding static information, while she recreated the experience through her painting; it was analogous to a preliminary drawing. Hers was not an exercise in artistic mimesis, but a recreation of an event that had inspired an intense, erotic experience and heightened awareness.

Although not buttressed by the same theoretical architecture, Pratt's intentions bear a striking similarity to those of Jack Chambers. His work, which also depended upon photographic sources, sought to recreate intense, religious experiences of acute awareness. He called the process of recreating them in art "Perceptual Realism," a complex and deeply personal artistic philosophy. Like Pratt, Chambers used photographs to record visual circumstances surrounding moments of clear, focused understanding of universal truth embodied in particular events. Although Chambers's method of using photographs in his work differed from Pratt's — he scaled up his photographic sources onto his painting surfaces, she projected them onto hers — for both Pratt and

Chambers, photographs gave coherence to transient events. Art structured the experiences and suggested their immanence.

By 1971, Pratt's work gained resonance, more than she would have believed at the time, when placed in the New Realist context. On one level, Pratt was simply responding to the isolation that she experienced in Salmonier, Newfoundland. She used the camera as a tool and the slide as a record. Unknown to her at the time, the New Realists were legitimizing this practice, even as she was doubting its validity. To the extent that she sought solace in the ordinariness of her world, content primarily to describe its presence and light — as did the New Realists — she became a "camera." She went beyond the singular dimension of unedited factuality, seeking to recreate experience through art and having it continue to provide discipline and meaning to her life. Had Pratt known of the emergence of New Realism, it might have allayed her doubts and she might have proceeded confidently on the path marked by *Supper Table* and *Eviscerated Chickens*.

Chapter Five
CELEBRATION

By the summer of 1971, after becoming reconciled to the place and use of photographs in her work, Pratt was, in her own words, "on a roll."[1] Donna left the Pratt household later that year, although she still posed for Christopher. Mary completed *Eviscerated Chickens* and began *Bags*, both of which were later purchased by the Art Gallery of Memorial University. She was exhibiting her work on "the mainland" at the Morrison Gallery in Saint John, New Brunswick, where she had a solo show in 1969, and in Toronto at Douglas Duncan's Picture Loan Society.[2] In Toronto, reviewers singled out Pratt's work as "workmanlike and unsentimental," and perceptively compared it to New Realism in the United States. Her choice of subjects injected a sense of the "monumental" to their apparent ordinariness, commented one reviewer.[3] However, if Pratt's art of the early 1970s symbolized an ordinary life, her own perception of the significance of her subjects underwent a transformation by the middle of the decade, when her work was featured in a second major solo exhibition at Memorial University.[4] "What I really want to do is celebrate the kinds of things I think are good about our society," she said in an interview in 1975.[5] From doubt and stasis came confidence and a career that she later described as "bombing ahead."[6]

Pratt had emerged from the dark night of creative paralysis that interrupted the completion of *Eviscerated Chickens* with renewed confidence. She found that her voice as an artist was given meaningful cadence through the use of photographic slides. "Until I began using the camera," she commented in 1975, "my subject matter was very limited. I couldn't do fish, or meat or cakes, or any of the things I really enjoy."[7] The mundane aspects of her life that once threatened to smother her creativity suddenly took on a greater

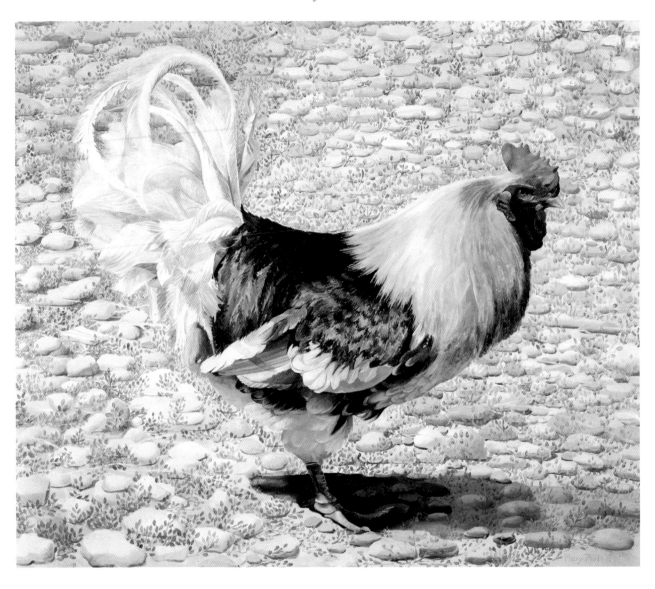

JACK POWER'S ROOSTER, 1971
oil on masonite, 53.3 x 61.0 cm
Private collection, New Brunswick

degree of significance; their apparent banality showed their revelatory potential. Salmonier acquired another dimension. An oppressive domesticity suddenly became pregnant with meaning. "The things that turn me on to painting are the things I really like," she allowed. "Seeing the groceries come in, for instance. Or cooking. I'm getting supper, and suddenly I look at the cod fillet spread out on the tinfoil and I think, 'That's gorgeous, that's absolutely beautiful.'"[8]

Pratt, it seems, was surprised by joy. Many of the paintings that she produced between late 1971 and 1975, among them *Jack Power's Rooster*, luxuriate in the warmth of the light that bathes the scene and in a technique that incarnates the vision that she came upon "by accident."[9] Stylistically, her work continued to be governed by the slide image, which she employed primarily to record light and subject matter. The presence of Donna and other domestic helpers gave Mary the time to experiment with a mode of painting in oils that was time-consuming. Employing small sable brushes usually used for watercolour painting, she painted in small cross-hatched strokes, using a relatively fluid medium of turpentine and stand oil. When the finished canvas was left to dry in a horizontal position, often for up to six weeks, the cross-hatch strokes would blend together, eliminating any evidence of brushstrokes. In effect, Pratt's technique suited her wish to make her paintings look styleless, like magazine reproductions or posters, while also permitting light to enter the surfaces of the paintings through the translucent layers of stand oil.

In addition to turning her hand to still lifes and interiors, Pratt also painted from the landscape in the 1970s. Her 1972 oil *Fredericton* was a departure, as she confronted the memories of her youth in the garden that was her hometown. In this painting, intense, pristine light rakes across the lawns and houses at early morning as if it were the very first morning. Her palette is keyed to blues and greens to accentuate the garden-like quality of the verdant landscape. Trees and ground vegetation appear to dissolve into abstracted orbs of light, shades and tones. The rich shadows act as dark voids penetrating the space of the painting in a manner similar to that seen in the work of Edward Hopper. The absence of figures heightens the painting's idyllic quality, allowing easy access into the imaginative space of Pratt's childhood.

As beautiful and nostalgic as *Fredericton* is, Pratt's most compelling images are her still lifes. Her 1972 painting *Red Currant Jelly* depicts the domestic ritual of preserving berries. Pratt's emphasis on the textures of the berries, the glass, the foil and the plateware

give room to her ability to capture light and to display a remarkable technical virtuosity. Her interpretation of the subject borders on sanctifying the ordinariness of the scene, while also alluding to a darker dimension — becoming, in essence, a celebration of a sanguinary rite.

Light and dark, the surfaces of Pratt's images draw the viewer in to their subjects, which frequently have a tenebrous undertone. For example, the theme of ritualistic killing in a domestic context is the subtext to three still lifes Pratt painted in 1974 and 1975. *Salmon on Saran* of 1974 is an extraordinary study of light glistening off the scales and reflecting in the surfaces of the transparent wrapping that appears to hover in space in front of the painting. In this work, Pratt chose to represent the moment immediately after the fish has been gutted and put on the Saran Wrap. Textures are illuminated by a direct light falling on the form. A strong contrast in the area of the gills creates both a void and a foil for the strong highlights on the gill-bone. Pratt softens the precise definition of forms and textures to draw attention to their allusiveness. She also heightens the amount of red in the painting beyond that in the original working slide. Although ostensibly a portrait of a dead fish, *Salmon on Saran* reveals Pratt's ability to give nuance to form, accommodating a greater latitude of possible interpretations and transforming the subject beyond its literal meaning. By drawing attention to benign cruelty in the service of sustaining life, *Salmon on Saran* is a disguised statement about all violence in society, even as manifested in the trivial activity of gutting a fish.

Variations on the same themes are embodied in *Cod Fillets on Tinfoil*, a visual essay on bright light reflecting off foil and fillets, which Pratt also painted in 1974. Like *Salmon on Saran*, the light in *Cod Fillets on Tinfoil* appears to hover in space in front of the painting's surface. The bright centre of the composition is the antithesis of the dark void of the earlier work. However, in *Cod Fillets on Tinfoil*, Pratt makes more explicit a sexual subtext of the subject through the enfolding parentheses of the foil and the abstracted, bleached forms of the cod fillets. The red staining in the bottom left quadrant of the

Mary Pratt's studio, 1972

composition introduces an undercurrent of violence in this apparently banal context, which, when placed next to the anthropomorphous forms, becomes sexual in nature. Even though the painting embodies an unsettling theme, *Cod Fillets on Tinfoil* is more than a veiled statement about sexual aggression. It is also about light and the subtle nuances of various qualities of light in the folded facets of the foil.

Pratt created a third still life at this time entitled *Eggs in Egg Crate*, which shows her technical skill and her range as an interpreter of common themes. Just as Pratt used light to illuminate subtle themes in *Salmon on Saran* and *Cod Fillets on Tinfoil*, she creates an essay on the description of light, textures and depth in a shallow illusory space in *Eggs in Egg Crate*. The spare subject matter, juxtaposed with the beautiful complexity of warm ochre and yellow tones of light playing off the surfaces, underscores the lyrical sexuality of her subject matter. Her treatment of this apparently ordinary subject is revelatory — the mundane is transformed into a metaphor of regeneration.

Pratt's choice of subjects and their domesticity led many to conclude that her art was autobiographical, "reflecting her role as wife and mother and . . . her acceptance of that role."[10] By 1975 Pratt's art was regarded as defining her own experience as a woman as well as that of women in Canadian society. But the line between autobiography and commentary was not entirely clear: Pratt, a female artist from Newfoundland who chose subjects from a domestic context, was being lionized as an example of liberation, yet her subjects were being denounced as traditional symbols of domination. This paradox characterized her relationship to the women's movement as it gained momentum in the mid-1970s.

"I think of myself quite consciously as a woman painting and I have quite strong feelings about the women's movement without really being a part of it," Pratt commented in 1975.[11] Indeed, Pratt recognized the paradox that she and her art represented in the growing politicization of the movement, and she was cautious about a close alliance to it. Recognizing the benefits of actively involving herself in the movement, Pratt worried that motives might be imputed to her if she allied herself to its causes. Fearing that "people will assume I'm trying to get ahead by using the movement," Pratt avowed that she would work within her own frame of reference. Ultimately, she believed that her art should remain autonomous and not be taken over by issues that lay outside of it. This was the route to creative fulfilment for herself and, she believed for other women.[12]

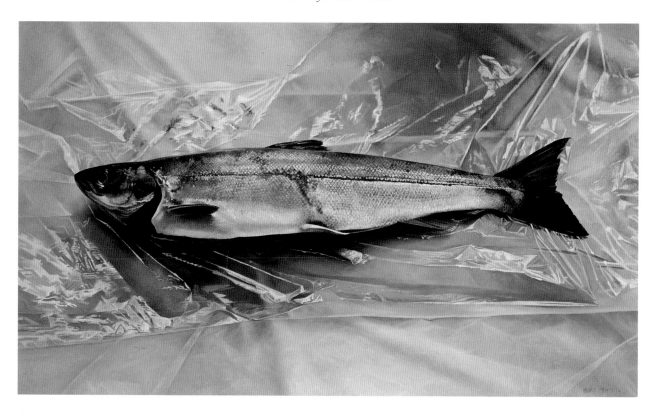

SALMON ON SARAN, 1974
oil on panel, 45.7 x 50.8 cm
Collection of Angus and Jean Bruneau

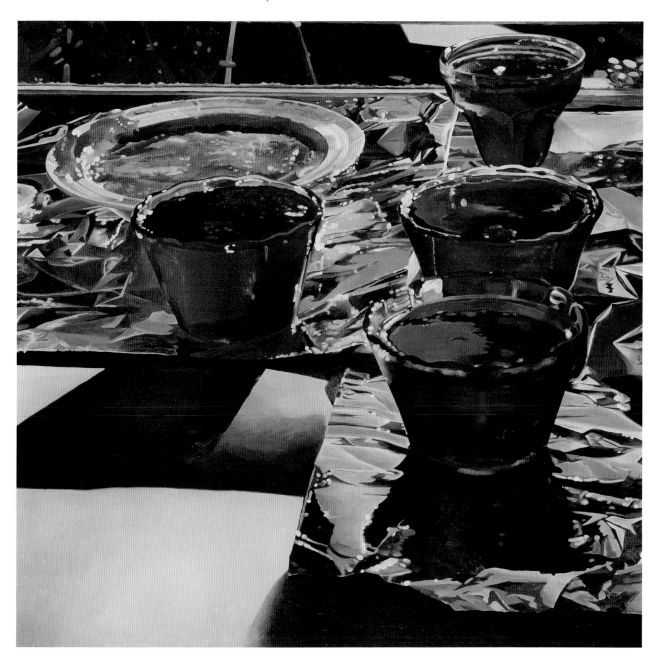

RED CURRANT JELLY, 1972
oil on masonite, 45.9 x 45.6 cm
Collection of the National Gallery of Canada, Ottawa

Despite her desire to remain on the margins of the women's movement, Pratt found herself being drawn into its centre in the mid-1970s. She was seen as the embodiment of the woman who selflessly abandons her own ambitions and aspirations, sublimating them to those of her husband and family, and who, after years of sacrifice, eventually finds fulfilment. Pratt had become the creative foil to her husband Christopher, whose own career was reaching a zenith. "The motive of [Mary and Christopher's] lives," wrote Harry Bruce in a national newsmagazine, "were his artistic priorities. Never hers."[13] Mary's success did create further tensions in her marriage. The fact that she was increasingly being taken seriously as an artist was difficult for Christopher to digest, and when the latent jealousies spilled into the open, they took on their own vicious momentum, at times going beyond what either Mary or Christopher could control. Although Christopher's relationship with Donna was an unexpected intrusion into their marriage, Mary was unprepared for the wedge that her own success would drive between her and Christopher.

Mary had come to the attention of the curatorial community largely as a result of the prominence of her husband. Two curators of contemporary Canadian art at the National Gallery of Canada — Pierre Théberge and Mayo Graham — were visiting Christopher Pratt during a tour of eastern Canadian artists' studios. It was while visiting him that Graham met Mary Pratt "by mistake."[14] While Théberge and Christopher were occupied with his work, Graham stayed behind and accidentally saw Pratt's *Cod Fillets on Tinfoil* on an easel in a side bedroom of the house. Thinking nothing of the casual conversation she had with Graham about the painting, Pratt was surprised a few weeks later when Graham invited her to participate in an exhibition called *Some Canadian Women Artists* that the National Gallery was putting together to celebrate International Women's Year in 1975.

Some Canadian Women Artists was conceived as "a recognition, a celebration" of seven women artists, among them Mary Pratt, who commented in the exhibition catalogue that her work "celebrated" surfaces and recorded her immediate reactions to their beauty.[15] In fact, Pratt's catalogue statement is almost apologetic in tone, as if she was uncomfortable exhibiting her work in the company of Gathie Falk, Sherry Grauer, Leslie Reid, Colette Whiten, An Whitlock and Shirley Wiitasalo. However, the self-deprecating voice of her catalogue note is countered by an authentic voice that gibes readers not to believe everything they read, even in artists' statements, particularly hers. "I have found that if I indulge in the nonsense of describing to anyone what I intend to paint," she

offers, "I never get around to paint it." Dwelling on the "mundanity" and "ordinariness" of her life and the "superficiality" of her subjects, Pratt suggests that she is not interested in putting forward a "moral" statement or selecting subjects that have "social implications." It is the surfaces of things, their textures, materials and reflections that attract her. "I simply copy this superficial coating because I like the look of it," she wrote.[16] "Presence," it would seem, prevailed over explanatory theory.

This interest in surfaces is only partially true. In spite of her modest mask — a hesitancy to suggest what is going on "beneath the surface" — Pratt's art contained a greater depth than even she attempted to plumb verbally. She might have been interested in the surfaces of things, which ostensibly *did* reflect a dimension of ordinariness, but by focusing attention on the ordinary Pratt sanctified it in dazzling luminosity and highlighted its dark underbelly. This inherent tension between foils gives Pratt's work its power to make clear and to mystify in much the same way as a sonnet by John Donne. Figure and ground change polarities as easily as egg yolks slipping through fingers.

Some Canadian Women Artists brought Pratt's art out of the shadows of her Salmonier studio, introducing it forcefully to a national audience. The exhibition was an ambitious step in redressing imbalances in the representation of women artists in exhibitions at the National Gallery of Canada and across the country. Mayo Graham attempted to find common qualities in the art of women, to synthesize disparate histories and motivations of women artists, and to examine the work of the artists she selected in order to isolate qualities that distinguished women's art from that of men. "Is there a female art?" Graham asked rhetorically in her catalogue essay; the exhibition affirmed that there was.[17] She suggested that women are interested in exploring textures, tactility, seriality, cumulation, cyclical repetition and an "emotive interpretation" of subjects. Pratt was singled out for the manner in which her domestic subject matter suggests "female traits," in which her pictures present a feminine point of view.[18] But in proposing a few rubrics that could be used in a larger project to define a female aesthetic, Graham was derided by critics as being too arbitrary or general.

Despite the fact that the thesis of the exhibition was challenged, critics and reviewers frequently singled out Pratt's work. Although her work was referred to as the most "traditional" in the exhibition, Robert Fulford declared in *The Toronto Star* that it was the "most memorable"[19] and suggested that *Salmon on Saran, Herring on Salt Bag* and *Eviscerated Chickens* were remarkable for the quality of their "craftsmanship."[20] James Purdie,

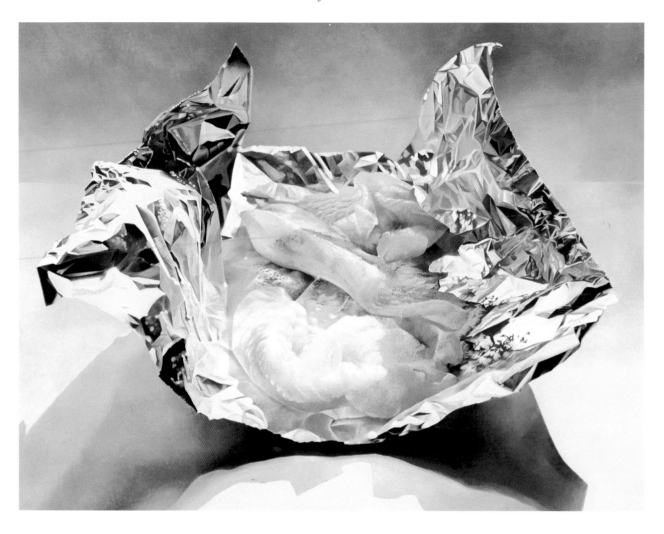

COD FILLETS ON TINFOIL, 1974
oil on panel, 53.3 x 68.0 cm
Collection of Angus and Jean Bruneau

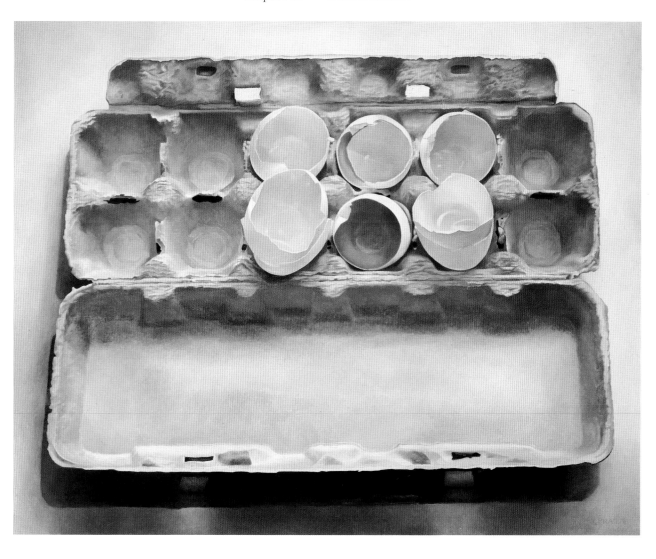

EGGS IN EGG CRATE, 1975
oil on panel, 50.8 x 60.8 cm
Collection of Memorial University of Newfoundland, St. John's

writing in *The Globe and Mail*, drew attention to Pratt's ability to express "a new way of seeing."[21] According to Susan Hallett, in a harsh review of the exhibition published in *The Canadian Review*, Pratt redeemed the whole project.[22] The most perceptive reviewer of the exhibition was Pratt's early supporter in St. John's, Peter Bell, who interpreted her interest in surfaces as celebrations of the "humble dignity" they represent. "She espouses order, the security of traditional morality, colour and warmth as concomitants of fellowship," he wrote. "Of these values her paintings are continually eloquent."[23]

Although Pratt's professional life was "bombing ahead," by the end of 1975 it caught her family in a swirling maelstrom of forces "beyond what anyone could control."[24] Her personal life was still in disarray, aggravated by a miscarriage of twins. The qualities of order, morality and fellowship implied in her paintings were mirages as transparent as Saran Wrap, but as real as one of her paintings would allow.

Chapter Six
ENGAGEMENT

"A direct and sensual engagement of the painter with her subject is what sets Mary Pratt apart from other realists on the Canadian scene," wrote Robert Fulford in 1976.[1] As a result of the National Gallery exhibition and the ensuing critical attention, Pratt was gaining notice. Early in 1976 her work was featured in a survey exhibition at Toronto's Aggregation Gallery, which was then establishing a reputation on the strength of its artists. Many artists in the Aggregation stable were working in a photo-realist mode; Joseph Devellano, Bruce St. Clair and Gillian Saward were represented by the gallery and, as an ensemble, were establishing a presence on the national cultural stage. Pratt found herself in good company. But the advantage was double-edged — she found herself being typecast. "[Pratt] wants to grasp the visual aspect of everyday objects and elevate them into art," Fulford continued in his "Note" for the Aggregation survey. "She wants to be . . . the visual poet of the kitchen."[2] And so it was that, by 1976, her art had been reduced to sound-bite proportions. Such a characterization was derogatory, patronizing and simplistic, but it provided a convenient encapsulation of Pratt's art that eventually contributed to her growing stature as an artist.

The first part of Fulford's portrait sketch is nearer the truth when describing Pratt's art. The inherent sensuality of Pratt's personal style and her sensibility were uncommon qualities among her contemporaries, even those at the Aggregation Gallery. Surfaces were important, but as transparent skins; when viewing her paintings, it was tempting to become preoccupied with only their brilliantly luminous surfaces at the expense of the depths beneath them. Form either hid meaning or gave its various layers

resonance. To become preoccupied merely with her subjects was to risk acknowledging her as a "visual poet of the kitchen."

Another critic looking at Pratt's *A Seven Year Survey* might have sensed that light is an active, dynamic presence in Pratt's paintings. What she records in paint is due to the capacity of light to induce vision. In the first instance, the activity of light on surfaces has evoked a strong, intense response, akin to sexual arousal. Her interpretation of form has been entirely governed by the light that allowed the photographic slide to come into being. Projecting the image as light onto her canvas or paper has reincarnated the moment of perception. Pratt gives viewers her vision by translating it into hues of paint. Light touching the surfaces is essentially a tactile action much like a caress; in Pratt's hands, light bathing forms is a metaphor of sensual engagement.

Pratt and Mayo Graham kept in contact with each other after the tour of *Some Canadian Women Artists* concluded. During a subsequent meeting, Pratt showed Graham a series of photographs that she had taken several years earlier of a moose carcass suspended from the winch of a wrecking truck. Although Pratt initially dismissed the image as being too obviously "political," Graham convinced Pratt to select one of the photographs for a painting, which she began in 1977.[3]

The progression to painting meat carcasses is an understandable movement from depicting fish and fowl. Her first painting in this genre, *Dick Marrie's Moose* (1973), is about a family's winter supply of meat, but to Pratt it also represented the dark side of rural Newfoundland, which, she believes, has a foundation in the cruel conquest of animals and nature. *Cod Fillets in Cardboard Cartons* and *Arctic Char* are variations on the theme first seen in her work of the early 1970s. In 1977, in *Roast Beef*, Pratt developed her interest in interpreting parcelled flesh as metaphoric of the unquenchable human appetite and the violence underlining the domestic ritual of Sunday dinner. But in these paintings the violent subtext is merely implied; in *The Service Station* the subtext is more explicit. When Pratt came upon the scene in a neighbour's garage, she was upset as much by its graphic violence as its ordinariness. "To me it screamed, 'murder, rape, clinical dissection, torture,'" Pratt wrote of her first reaction to seeing the slaughtered moose. "All the terrible nightmares [were] hanging right in front ofme."[4]

Through the image of a moose killed and butchered during the annual autumn hunt, Pratt found what she referred to as a "female statement about a male world."[5] Yet she preferred not to have the statement's political dimension overtake its inherent

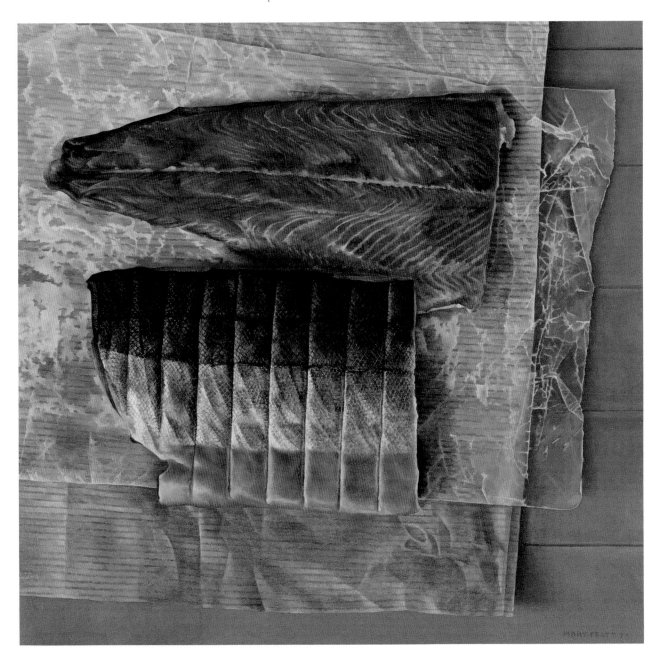

ARCTIC CHAR, 1978
oil on masonite, 61.6 x 61.6 cm
Collection of David P. Silcox

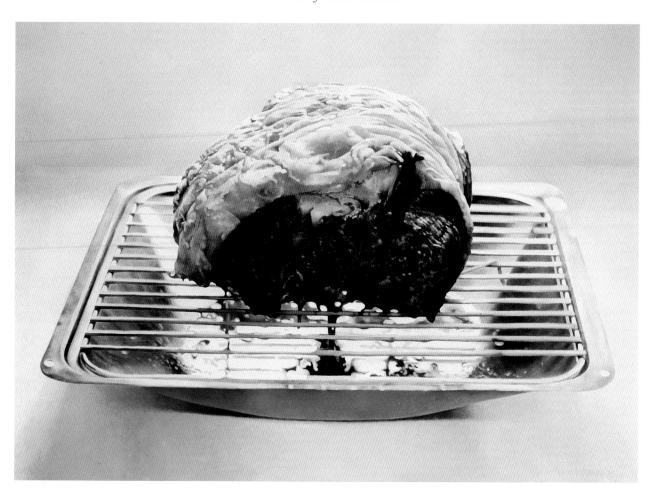

ROAST BEEF, 1977
oil on panel, 41.9 x 57.2 cm
Collection of the London Regional Art Gallery and Historical Museums

graphic force. Above all, *The Service Station* reflects Pratt's consummate skill and crafts-manship and her ability to create an image whose force extends from the many possible meanings that could be ascribed to it — sexual, religious, social or economic. It is animate in its rawness, like Rembrandt's *The Carcass of an Ox*, which Pratt had seen in Glasgow. When exhibited in the spring of 1978 at the Aggregation Gallery, *The Service Station* received favourable critical novice.[6] Writing in *The Globe and Mail*, James Purdie com-mented on the contrast between the "untouched" hooves and the butchered carcass as a "forlorn and incidental reference to life in the overwhelming presence of death [which] is the paradox and triumph of the painting."[7]

Another Province of Canada, also shown in the Aggregation exhibition, is a variation on the theme of *The Service Station*. The gutted fish — its skin and flesh — has an anthro-pomorphic quality. Pratt's interpretation of form alludes to a vagina and labia into which a young man has thrust his hand and, by inference, a knife. Just as Pratt intended *The Service Station* to call forward images of "murder" and "rape," so in *Another Province of Canada* the inherent violence of fishing is presented as a metaphor of sexual violence, rape and dismemberment. Although Pratt displays consummate technical skill in representing the quality of light of the scene, her skill pales when compared to her ability to show the transformation of an ordinary aspect of fishing into an expression of sexual violation.

Indeed, the inherent tension in Pratt's imagery is due to its potential to transform itself — a salmon is not simply a fish, but a metaphor of violence; a gutted carcass is a trophy of a hunt, a winter's supply of meat, a crucifixion, a metaphor of human vio-lence. Many potential meanings rest in each of Pratt's images. Pratt chose a domestic metaphor to explain her thought process. "Tonight I am going to try to show you where I get my images. . . . I guess I mean *how* I get them . . . how I look at my world to come up with the paintings I eventually produce," she wrote in her journal in 1977.[8] She went on to describe her method of selecting subjects as akin to that of a "fussy house-keeper" who constantly adjusts furniture, polishes surfaces, arranges bric-a-brac "just so." Like the housekeeper, Pratt went about ordering her world in a similar manner, except that the tableau replaced the household.

To a large extent, this description provides an image of Pratt at her easel. However, it proves inadequate when her subjects metamorphose into sexual metaphors. If the play of light was her art's text and sexuality its subtext until the mid-1970s, subtext had become text by the end of the decade. When asked in an interview in 1979 whether her

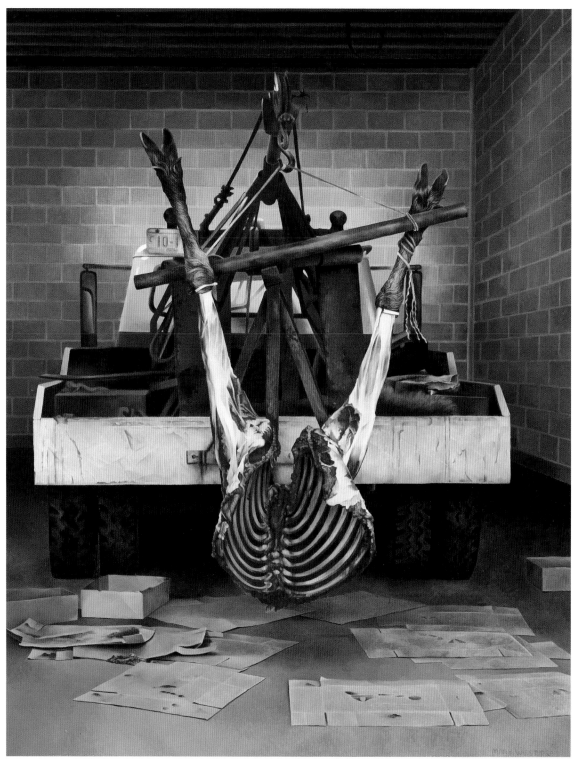

THE SERVICE STATION, 1978
oil on masonite, 101.5 x 76.5 cm
Collection of the Art Gallery of Ontario, Toronto

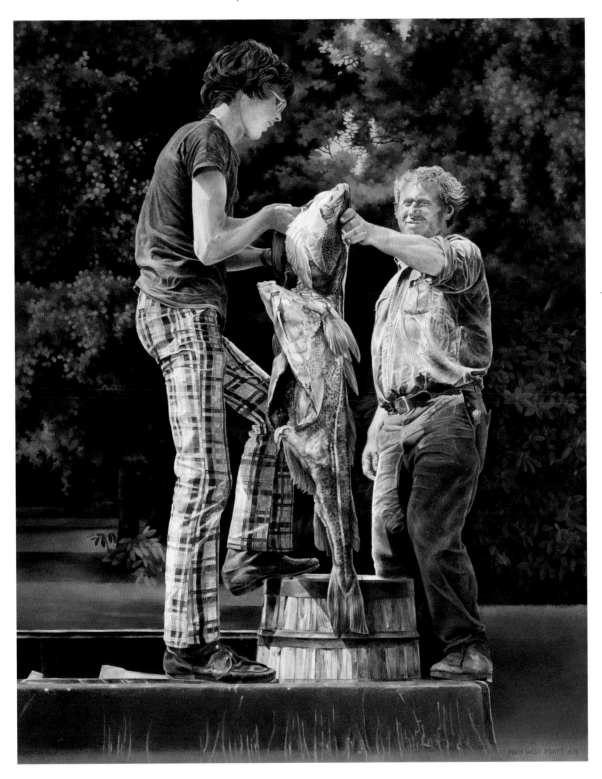

ANOTHER PROVINCE OF CANADA, 1978
oil on panel, 91.4 x 70.0 cm
Collection of Memorial University of Newfoundland, St. John's

work was erotic, Pratt replied, "I don't think I would ever do a painting where the subject didn't turn me on. I really mean turn me on."[9] Reflecting on her selection of subjects, Pratt commented that it was not necessary simply to paint nudes to create an erotic tableau. Flowers, fruit, vegetables and still lifes were all capable of engendering in her an erotic attraction which she sought to transmit to viewers through her resonant images. Probing the qualities of the erotic experience, Pratt went on to say, "when the light comes in the window and hits something, to me that's an erotic experience and I don't know whether that's acceptable, but it's true."[10]

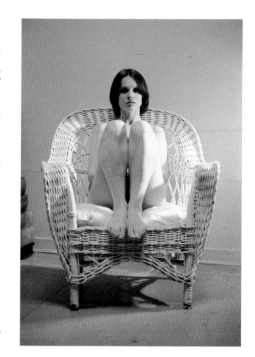

For Pratt, the erotic impulse was a quality of light and of subject; light touching materials and textures, subjects giving rise to intimate associations, both conspiring to create a means of sensual engagement, of arousal through interacting with the work of art and interpreting its subject matter. Commenting on *The Service Station* and *Another Province of Canada* in the same interview, Pratt allowed that "the fish and the flesh of the moose are fairly erotic." Although Pratt might have described herself as a "bullying" housekeeper, her selection of images was largely dependent on their capacity to give her "a bit of a kick."[11]

Mary Pratt's 1978 painting *Girl in Wicker Chair* is her first interpretation of a female nude. Christopher Pratt had shown Mary a collection of slides he had taken of Donna while she was his model and asked if they might be of interest to her. Donna had left the employ of the Pratt family seven years earlier but continued to model for Christopher, and, since he worked directly from the model rather than from photographs, the collection was of little use to him. To Mary, the image of Donna sitting in a wicker chair "seemed too perfect to throw away."[12] She was attracted to the slide by the formal qualities of the image — the symmetrical balance of the pose, the quality of light raking across the model's body. She also wanted to explore the subject for what it told her about the relationship between artist and model, her husband and Donna. She wanted

35-mm slide used as the source for GIRL IN WICKER CHAIR

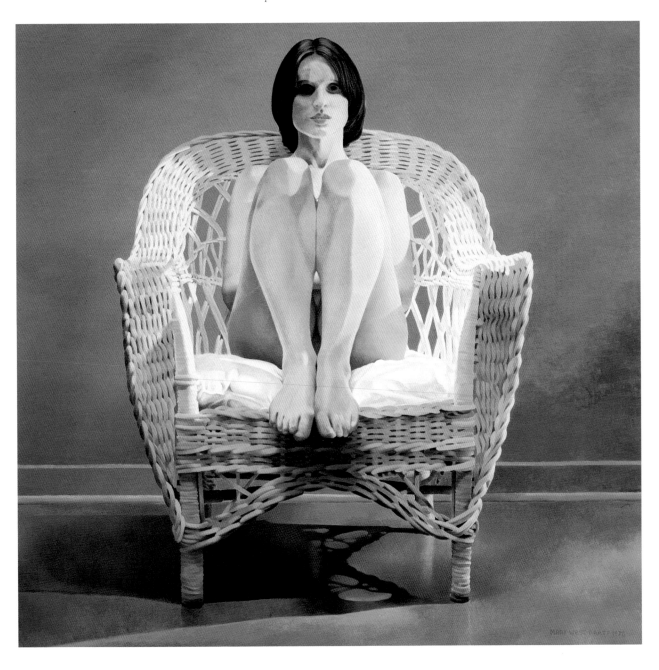

GIRL IN WICKER CHAIR, 1978
oil on masonite, 96.3 x 84.0 cm
Private collection

to probe the relationship by studying the slide taken by her husband of the model looking at him. The photograph was Christopher's image, her found object.

Girl in Wicker Chair is the first in a series of nudes that Pratt completed throughout the following decade. She continued to work from slides of Donna taken by Christopher and, later, her own slides. Rather than choose from those in the original collection given to her, Mary Pratt asked her husband to take contemporary photographs of Donna in predefined poses. For example, she wanted to work from an image of Donna in a housecoat. But, rather than buy a new housecoat, Pratt gave Donna her own. The subsequent photographs eventually became the source for her 1981 painting *Girl in My Dressing Gown*, her 1986 painting *Donna* and her 1987 canvas *This is Donna*. Mary Pratt was not present at the photo sessions. Instead, she preferred to receive a slide of a nude woman looking at her husband in her absence. Above all, she wanted images that betrayed intimacy through the gaze of the model directed not just at her husband but, ultimately, also at viewers of the finished paintings. Moreover, using what she saw as Donna's strong sexual presence, Pratt wanted to explore the concept of female sexuality as an erotic muse to men, and she particularly wanted to understand her husband's erotic muse. She admitted that in the first series of female nudes, she was declaring, "This is what women are like. This is what men find erotic."[13]

Pratt's frankness hid a hint of pathetic irony. If she wanted to pose rhetorical questions about perceptions of desire, she probed their answers through images of female vulnerability — closed, defensive poses, masks of insouciance hiding tentative, questioning looks of helpless nakedness. The nudes are posed against walls, backed up against them as if cornered in pursuit. The model's inwardness seems to heighten a sense of a gratuitous voyeuristic pleasure at the expense of her self-esteem. By exploring what men and her husband find arousing through her early nudes, Pratt presented images of female defencelessness; in her painting *Girl in My Dressing Gown*, Pratt records defiance.

Mary's nudes are the very antithesis of Christopher's. Where Mary's are specific depictions of a particular person caught by the lens in a domestic drama, Christopher's are general descriptions of an archetypal presence of a different temperament.[14] This is particularly true in his nudes of the mid-1960s. To Christopher, the female nude is interpreted virtually as an idealized muse, the source of his creativity and inspiration. His characterization of the female figure is deliberately anonymous in order to diminish any sense of physical engagement between artist and model, viewer and nude. In the

mid-1970s his approach to the subject of the female nude turned from the model as muse to artistic creativity, to model as muse to sexual fantasy.[15] By the early 1980s his work acknowledged the model's persona and sexuality both by commenting directly on the relationship between an artist and a model, and by describing his own encounter with a model in his Salmonier studio. The possibility for arousal simply does not exist in his neutral interiors. Next to Mary Pratt's *Girl in My Dressing Gown*, Christopher's nudes appear arid, almost clinical in their definition. His innate passion is suppressed, whereas Mary's nudes are passionate, challenging, sexually charged images. It is as if Mary is Christopher's alter ego.

Throughout the last half of the 1970s, Mary Pratt's career continued to gain prominence. The Aggregation Gallery realized the marketability of her work and promoted it across Canada while struggling to situate it in the context of the New Realists. Mary's work was also attracting a degree of notoriety. When a photographic reproduction of the painting *Girl in a Wicker Chair* was published on the cover of the September 1978 edition of *Saturday Night*, it caused subscriptions to fall off, mostly in protest against the painting's perceived pornographic nature. Mary's work was also included in a major exhibition organized in 1976 by The Gallery in Stratford, entitled *Aspects of Realism*, which toured the country, and a second exhibition in 1978, mounted by the Norman Mackenzie Art Gallery in Regina, entitled *Realism in Canada*. At the Aggregation Gallery, Pratt was featured in a group exhibition in 1977, and in a second solo exhibition in 1978.[16] Curators at public art galleries in Canada were also beginning to acquire

35-mm slide studies and slide used as the source for the painting
GIRL IN MY DRESSING GOWN

interest in Pratt, picking up the thread where the National Gallery had left off after *Some Canadian Women Artists* closed. Joan Murray, director of the Robert McLaughlin Gallery in Oshawa, wrote what was at that time one of the more perceptive articles dealing with her art.[17] Paddy Gunn O'Brien, of the London Regional Art Gallery, proposed that a retrospective exhibition be mounted in 1981. By the end of the 1970s, Pratt had been able to carve a professional identity of her own, distinct from that of her husband, her reputation resting solidly on the technical qualities of her work, its engaging imagery and the subtlety and resonance of its meanings. By reflecting her own experience, her art was lifted beyond its particularities, offering emblems of collective experience, "female statements about a male world."

Opposite: GIRL IN MY DRESSING GOWN, 1981
oil on panel, 153.6 x 77.5 cm
Private collection, Vancouver

BOWL'D BANANA, 1981
oil on panel, 50.8 x 61.0 cm
Collection of Richard and Sandra Gwyn

Chapter Seven
TRANSFORMATION

Mary Pratt's opinion of the retrospective organized by the London Regional Art Gallery in 1981 was that it showed she "had not developed very far."[1] It was a time to pause, to take stock.[2] The exhibition provided the artist and her viewing public with the opportunity to review thirteen years of artistic production and to judge its success. Unfortunately, the brief catalogue essay by Joan Murray did not take advantage of the occasion to synthesize Pratt's career, although its author teasingly hinted that more was going on below the "surfaces" of the work than she or other writers intimated. Through the surfaces of her paintings, wrote Murray, Pratt "apprehends the mystery of life."[3] But Murray neglected to describe how Pratt's vision transcended the banal to penetrate its universal essence. That would be left for Pratt herself.

The experience proved cathartic for Pratt because it allowed her to purge many of her feelings about domestic images. After seeing the retrospective's assemblage of paintings that had helped to structure her life, bringing her back emotionally from a point of near collapse, Pratt discovered that she felt oddly ambivalent about them. "We had outgrown each other," she commented. From her point of view, the retrospective was a reverential goodbye to housework.[4] She no longer wanted to be regarded as a "kitchen housewife painter," but as a painter.[5]

In truth, Pratt's work had become more self-referential by the early 1980s, in the same manner that a panel painting by Vermeer comments on the process that led to its coming into being. Like Vermeer, Pratt acknowledged the properties of the photographic image and its narrow depth of field. *Bowl'd Banana*, a painting completed in

1981, is a gentle homage to Vermeer, expressed in a still life seen through a glass bowl. Pratt delights in the description of light as it activates surfaces of lace, glass and fruit. She emphasizes different qualities of light playing on the surfaces: direct, reflected and refracted light stand in contrast to the surfaces of the fruit. Although Pratt avoids ascribing specific symbolic meaning to this work, its celebratory aspect encompasses the theme of nature's abundance and fertility as conveyed by a bowl of fruit.

Throughout the 1980s, Pratt also continued to paint female nudes as an exploration of the theme of voyeurism. *Blue Bath Water*, an oil painting that she completed in 1983 from a slide taken by Christopher at her request, interprets the female nude splashing in a large white tub, the pearlescent light reflecting on her skin as she emerges from the dyed bath water.[6] Because of the water's opacity, the nude is almost playful, not sexually arousing as the artist had expected. Her identity is shielded, her face turned from the viewer, seemingly unaware of the spectacle she is creating as the audience voyeuristically looks on.

In contrast, the model for *Cold Cream*, painted that same year from a slide that Mary took, confronts viewers directly as she looks out through a mask of cold cream on her face. Just as *Blue Bath Water* is primarily a study of the smooth textures and colours of female skin, *Cold Cream* adds an extra dimension by commenting on the alteration of colour and texture cosmetically as an analogue of the painting process itself: the model paints her face, Pratt paints the portrait of the model. The artist's handling of the oil medium is more painterly than her earlier work, a direct reference to the method of applying cold cream in thick layers across the face. Through this painting, Pratt comments on the paradox of female identity: the process of making oneself attractive is itself unattractive. Even as the female model is creating an identity through the application of cosmetics, her actual identity is shrouded in a mask of pigment. Ironically, in a work that is undeniably painterly in its application and in its commentary on the thick impasto layer of cold cream on the model's face, Pratt wrote that she "hardly used any paint at all, most of the white is underpainting gesso."[7]

During the early 1980s Pratt presented a conundrum to the community of art critics. The catholicity of her subjects and themes made it difficult for her to be pigeonholed. From a critic's point of view, her progress after the retrospective made little obvious sense.[8] Her subjects ranged from still lifes to figurative work to landscapes, among them the spare seascape, *Entrance*. In her oeuvre, the celebratory depiction of fruitful abundance

Opposite: BLUE BATH WATER, 1983
oil on masonite, 170.2 x 115.5 cm
Private collection

ENTRANCE, 1979
oil on masonite, 85.4 x 121.9 cm
Collection of The Beaverbrook Art Gallery, Fredericton

COLD CREAM, 1983
pencil and oil on gesso on masonite, 48.3 x 41.9 cm
Collection of the Canada Council Art Bank, Ottawa

as seen in the 1984 painting *Blue Grapes and a Yellow Apple* coexisted with work that posed questions about sexual identity and the nature of voyeuristic pleasure. Moreover, works that contain a veiled sacred message, such as *Child with Two Adults*, and works that contain a subtle gruesomeness, as expressed in *Fish Head in Steel Sink*, were both painted in 1983. Pratt was examining the similarity between apparently divergent subjects and themes by exploring, with increasing depth and nuance, the metaphor of a radiant muse incarnated as light. Light creating the vision in Pratt's paintings is a resonant sexual metaphor that both celebrates the muse transformed as abundance and gives dark witness to its inverted spectre: the carnal muse, dominatrix or innocent participant in a vicarious sexual encounter.

Pratt was certainly carving out new creative territory for herself by exploring the multidimensional aspects of the organizing myth of her artistic practice. Few contemporary women artists in Canada painted the female nude with the same force or sense of engagement, let alone interpreting it through an erotic scrim. Pratt was virtually on her own as a woman artist, invading a subject that had been the preserve of male artists. If the female nude was a personification of the creative muse for men, Pratt asked, what was the comparable creative muse for women? To probe the question, Pratt examined and interpreted images of Donna, her husband's muse. Still the answer eluded her, perhaps because she felt inhibited about being in the physical presence of a nude woman. She needed Christopher as her surrogate to photograph the nude Donna.

Nevertheless, the sophistication and complexity of Pratt's imaginative world, reflected in the myth of the radiant muse, are born from a process of associative thought in which the world and things in it are constantly transforming: light becomes flesh, becomes fruit, becomes fish, becomes a slaughtered animal; currant preserves become blood in an offering poured into the river of time; a church becomes a boat turned upside down. Such is Pratt's process of thought, trusting the power of metaphors to shape the world.

As the decade of the 1980s unfolded, Pratt articulated the myth in her work and sought to understand the process of thought that provided the images for her art. "The reality comes first, and the symbol comes after. And that's the way my work is," commented Pratt in an interview in 1985. "I see these things, and suddenly they become symbolic of life."[9] When asked about the technical ability that allowed her to describe the effects of translucency and transparency of materials, Pratt provided the following anecdote:

When I was a child I used to have to go to church. We went to church
as a family. . . . I used to go to church and think about the windows or
whatever was around, and I used to look at the stained glass windows
and think: "If you were a really good painter you could paint that light,
and you wouldn't just do it by putting on transparent paint. You should
be able to discern the tones — from dark to light — so that you paint in
translucent transparency, not by cheating and using just glazes." I used
to sit and think how to get that red to look really transparent. . . . I guess
I decided when I was just a very little child that a real painter could paint
anything.[10]

Pratt's direction as an artist had announced itself in a vision in Wilmot Church. It was
her obligation to equip herself technically to succeed without "cheating." As a child,
Pratt made up stories in which one idea led to another. Letting one image slip into
another was a pleasurable indulgence that she carried over into her adult years and into
her profession as an artist. "It was fun. But there was not much point," she allows.[11]

But as Pratt matured as an artist, the process of transforming metaphors gained
greater credence for her, and naturally led her to consider turning to film-making as a
creative vehicle. In 1985 she described in words and through illustrated storyboards
her ideas about a possible film and the images that would transform themselves into
others. Although the following description has a filmic quality, it encapsulates Pratt's
method of thinking — the structure of her thought — that prompts her to select subjects
and images:

I've always wanted to work in film, but it's impossible where I live. . . . I
thought, what if they were just to fill up the screen with red? It would just
be red on the screen and there would be "MARY PRATT" in gold. Then they
would take all the printing off, and then you'd realize that you'd seen the
red out of focus, and it would be all bubbling and you'd realize that you
were looking into a cauldron of bubbling jelly before it's ready. Then the
camera would move down and you'd see the rim of this big, stainless steel
pot, and the pot would move up, and the string of jelly would go down
into its jelly jar, and it would fill up with red, and then the red jelly jar
would turn into a glass of wine, and it would be a darker red, and as you
looked at this beautiful image it would be come a goblet with gold and

BLUE GRAPES AND A YELLOW APPLE, 1984
oil on board, 54.0 x 69.9 cm
Collection of Mr. and Mrs. Ken Soon

CHILD WITH TWO ADULTS, 1983
oil on board, 54.5 x 54.5 cm
Private collection

gems. And in the back would be the Aegean Sea; it would become this wonderful classic goblet, and then you'd see the hands of a priest, and you'd know it was a priest because we'd have some lace, and he would pick up the goblet and bring it to his mouth, and then we would see this long lace, and it would turn into a christening gown. You would see his hand flicking water from the goblet now turned into a fountain, and the water would turn into rain, and you would see the rain falling down into the river through a lace tablecloth that would be in the backyard, hung by plastic clothespins to the line. Then you'd see Christopher out fishing, and he would catch the fish and dash it on the stones, and you'd see the blood again. So you're always bringing realism, real situations into symbols so that everyday situations suddenly become the symbols, and that is the way I work.[12]

Above and opposite: STORYBOARDS, c. 1985
watercolour on paperboard, 35.6 x 41.3 cm
Collection of the artist

If the essence of Pratt's thought process is imbuing the ordinary with symbolic resonance, she evades ascribing meaning to her symbolic language. "That's up to you," she replies in response to an interviewer's question about meaning. For Pratt, observing the "reality" of the event precipitates a series of associations and a string of images. The phrase, "I see things and suddenly they become symbolic of life," neatly embodies her thought process, while suggesting the nature of the intense perceptual moments and erotic responses that caused her to select images for her work. A thing, an event, a still life or a landscape become open-ended metaphors transformed by their presence and by the imaginative capacity of the viewer to become immersed in their possible meanings.

From reality to metaphor to reality, Pratt's imaginative world is not bound by the limits of critical discourse. Thus, the sensual and the sexual co-exist in her work. The line between the sacred and the profane is blurred as softly as the veil that separates the

FISH HEAD IN STEEL SINK, 1983
oil on panel, 52.1 x 77.5 cm
Private collection, New Brunswick

WEDDING DRESS, 1975
oil on panel, 116.8 x 61.0 cm
Private collection, New Brunswick

appreciative act of looking at one of Pratt's paintings from the invasive act of voyeurism. Banal domestic rituals take on dark significance. The underlying spectral presence in the preparation of a dinner bears witness to atrocities of apocalyptic proportions. The natural regeneration of a rainfall becomes a sacred emblem of purity.

Pratt's 1986 exhibition, entitled *Aspects of a Ceremony*, was the first of several "thematic exhibitions" that she conceived for a commercial gallery.[13] Although Elizabeth Nichol, the director of the Equinox Gallery, first suggested in the mid-1970s that Pratt create an exhibition of paintings on the theme of a wedding, the images for this show resulted from the weddings of Pratt's own daughters. The genesis of the theme, however, dated back to an event in Pratt's life when she was babysitting for a woman who told her that she had sold her wedding dress after having had it cleaned. As a young woman, Pratt was "appalled." She could not imagine selling a wedding dress, much less cleaning it. Visions of a wedding dress hanging on a clothes line remained with her into adulthood.[14] The paintings of 1985 and 1986 forming *Aspects of a Ceremony* portray the sacredness of the wedding ceremony through an ironic sensibility. Meditating on the two ceremonies, Pratt wanted to express her ideas about commitment at a time in her life when the definition of the word was being severely challenged and her own marriage was in danger of collapsing. She wanted to probe what she had considered the important dimensions of commitment by treating her daughters as manifestations of herself. In Pratt's hands, the nostalgic romanticism surrounding the ceremony is drawn aside, exposing vulnerability and emotional isolation.

The tension between the sanctity and profanity of the ceremony is best encapsulated in the two paintings *Wedding Dress* and *Donna*, both completed in 1986. Pratt first treated the theme of the wedding more than ten years earlier when she completed the 1975 painting entitled *Wedding Dress*. The work stands in marked contrast to the painting with the same title completed in 1986. Both works interpret the subject of the dress hanging. In the 1975 painting, Pratt emphasizes the virginal cleanliness of the garment. In the later painting, the classical purity of the dress is interrupted by the intrusive form of a tree-trunk. Portraying the light passing through the cloth, Pratt created a translucency whose innocent purity is abbreviated by the contrasting form of the tree, which, like the light, penetrates the surface of the cloth. To Pratt, the casual image of her daughter's wedding gown playing in the breeze embodied the hopes and the pathos of the ceremony.

On one hand, *Wedding Dress* is a lyrical statement about the sanctity of regeneration; on the other, it is an elegy to innocence. Pratt explored the latter in *Donna* by expressing the vulnerability of the naked woman, while at the same time showing her as tough and defiant.[15] On its surface, *Donna* is a virtuoso essay about light: direct light throwing the forms and textures of the nude into relief; indirect light softening the harsh contrasts between dark and light. Strong shadows and reflected light illuminate the underside of forms, giving a greater spectrum of flesh-tones than would be seen if the light came from one source. Light, in all its dimensions, plays on the model, touching lightly or harshly the entire surface of her body, a sensation that is accentuated both by the model herself touching her legs and by the impressions of socks evident on her ankles. The warm light also tends to cast the figure back in space, a movement that is militated against by the wall, which confines the nude between it and the picture plane.

A mood of apprehension is reinforced in the painting as much by the play of light as by the model's attitude and defenceless pose. A restrained sexual tension is suggested by the mere act of looking at the painting. Pratt has made its viewers voyeurs as they engage the model's steady look. Indeed, to look at *Donna* is to echo the touch of light. The neutral ambiguity of the model's gaze seems to invite inspection, yet she appears to be uneasy about the implicit judgment arising from the act of looking. The model is also sexually alluring; a subtle eroticism and emotional inaccessibility are the properties of what is shown the viewer and what is left unrevealed.

The themes of celebration and vulnerability that Pratt expressed through *Aspects of a Ceremony* are also evident in the two paintings of 1986 that show her daughters in their wedding dresses: *Anne in my Garden* and *Barby in the Dress She Made Herself*. In both paintings, Pratt explores the complex set of emotions bound up in the ceremony and the intense pressures upon young women to find romantic love. In *Anne in My Garden*, Pratt captures the spirit of a Pre-Raphaelite painting of serene feminine presences in long, flowing robes of white, but she presents it in the contemporary setting of her backyard in Salmonier. In this painting, Pratt emphasizes the dislocation between the figure of her daughter, looking for all the world as if she had been lifted from a Dante Gabriel Rossetti composition, and the garden landscape intersected with the lines of telephone and electric wires. If the figure of her daughter Anne expresses the timeless wish of young women for what Pratt refers to as "the Romantic hero," the figure of Barby conveys the humanness of the wedding ceremony.

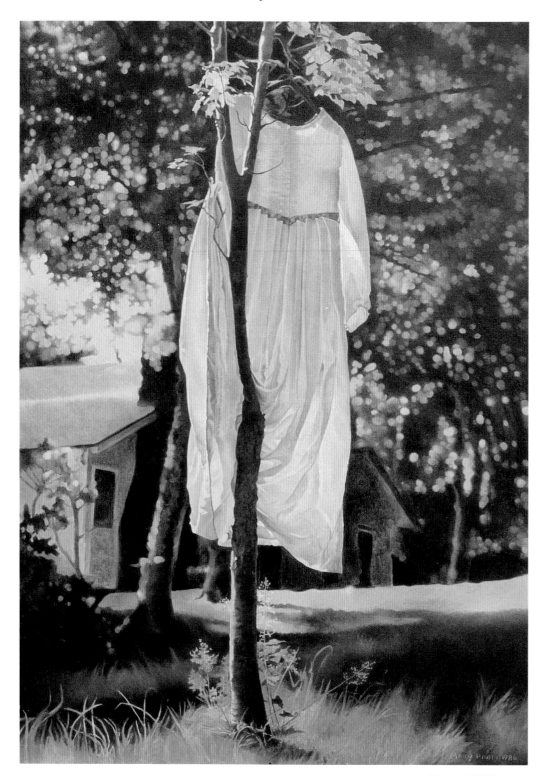

WEDDING DRESS, 1986
oil on panel, 74.3 x 57.2 cm
Private collection

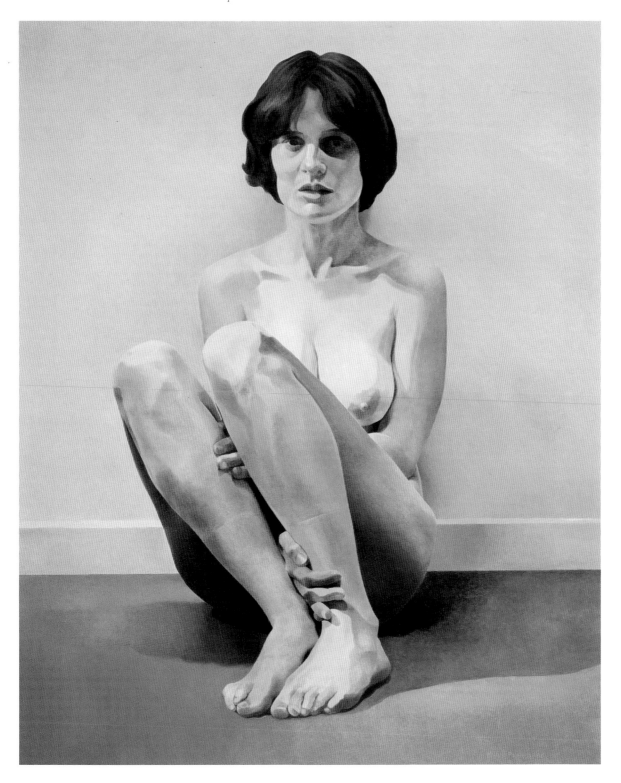

DONNA, 1986
oil on panel, 89.9 x 70.5 cm
Collection of Memorial University of Newfoundland, St. John's

Although Pratt's wedding paintings are essentially meditations upon the significance of events surrounding the marriages of both of her daughters in the same year, they also reflect her examination of her own marriage, the complexities of human dependence. Although it was through Donna's early relationship with Christopher as his model that Mary came to understand more deeply than before her own relationship to him, by 1986 it was of little concern to Mary. Rather, through her *Aspects of a Ceremony* paintings, Mary examined the drifting apart of husband and wife, the fact that her early acceptance of marriage as a "safe harbour" was not going to work for her any longer.[16] In the summer of 1986 she wrote in her journal that her relationships were themselves transforming. She felt encumbered but also encumbering; she was surprised at the intensity of the rage that she could direct at her husband; she realized that she could be evil and that her darkness could cast a smothering pall over her world. Mary could not be as generous as she would have liked. "I am caught here as surely as a fly is caught in a spider's web," she wrote, as she realized that the "influence of evil is very strong, and the love and grace I had hoped would gild my personal relationships was too weak to overcome the cynicism that evil produces." The evil that she believed existed on the periphery of her world had invaded its centre, tainting her life. "I found that I was the one in which all evil rested. People whom I had rejected were actually good," she wrote. "The web was my own, and instead of the fly, I was the spider." She now found herself in the double role of betrayed victim and betrayer; the strength that she needed to survive was expressed in the eyes of *Donna*.[17]

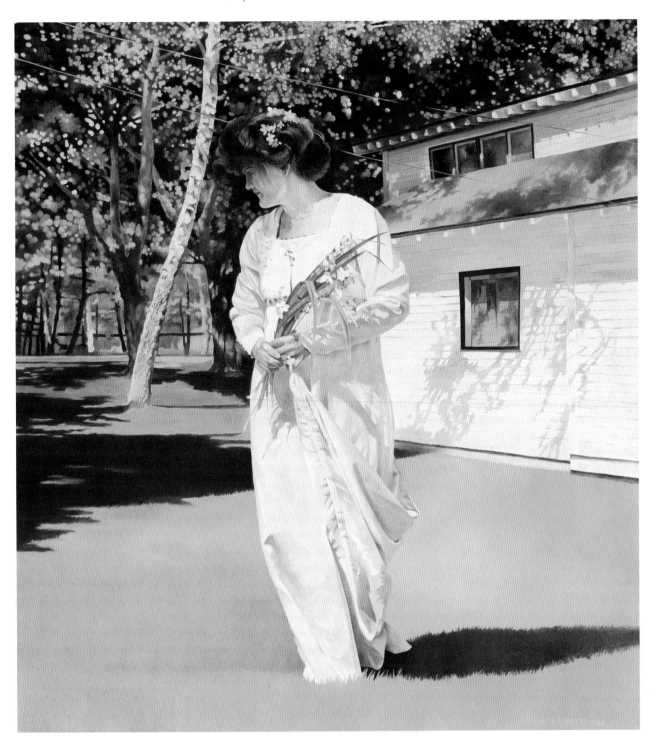

ANNE IN MY GARDEN, 1986
oil on board, 76.2 x 66.0 cm
Collection of Charlotte Wall

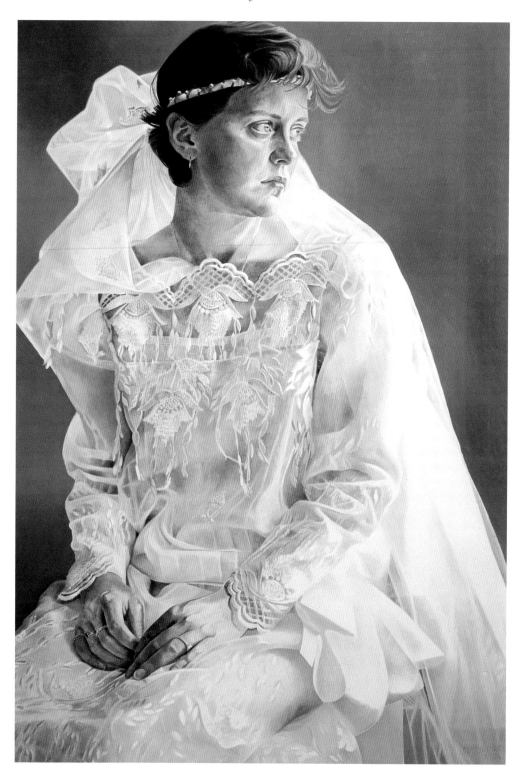

BARBY IN THE DRESS SHE MADE HERSELF, 1986
oil on panel, 90.8 x 60.3 cm
Private collection

Chapter Eight
REVELATION

"Do not be deceived by the woman standing patiently before you. She only appears to be the epitome of modesty, composure and reticence," declared the Memorial University orator addressing the 1986 Convocation; the degree of Doctor of Letters, *honoris causa*, was about to be conferred upon Pratt. Although she appeared modest, Pratt's career was accelerating. She moved from the Wynick/Tuck (formerly the Aggregation) Gallery and was now represented by the Mira Godard Gallery, one of the country's more prominent commercial galleries. In the early 1980s, she served on the Federal Cultural Policy Review Committee (the Applebaum-Hébert Committee) which examined the entire structure of funding for the arts in Canada, and in the late 1980s she was a member of the Canada Council. Pratt was also a member of advisory committees selecting public sculpture commissions and directors of art galleries. She chaired the Advisory Committee to Memorial University on the School of Fine Arts at Corner Brook. Her contribution to the cultural life of the country was recognized, not just by Memorial University, but also by Dalhousie University in 1985, St. Thomas University in 1989, the University of Toronto in 1990 and Mount Allison University in 1992, all of which conferred honourary doctorates on her. Indeed, in the last half of the 1980s, Pratt enjoyed an increasingly central place on the national cultural stage. She was sought out for her opinions and expertise on cultural matters and her work was featured in articles in lifestyle magazines.[1] Her painting *Decked Mackerel* was one of seven works of art chosen for the project *Painting the Town*, sponsored by Manufacturers Life Insurance Company of Toronto. Her painting was reproduced in the size of a commercial advertising billboard and displayed in major cities around Canada. Yet, in spite of her

achievements, she worried about the effects of her ascendance on her family. Success in the arts was considered by Pratt to be "obvious and garish" and "an obstacle" for her family. When faced with her growing reputation in the arts, Pratt wrote that her public face was a "veneer of tough ego-tripping," while in private she "locked the door of my studio and cried in front of the easel."[2]

 This is Donna, a painting that Pratt completed in 1987, appears to embody the Janus-like character of Pratt's public and private faces. In this confrontational portrait, the model challenges viewers directly, with a posture expressing a defiant, self-assured pride. The model's gaze betrays modesty, a lack of conviction in striking contrast to the immodesty of her presentation. *This is Donna* is an expression of the paradox that Pratt herself felt at the point in her life when the public artist and the private woman were a jumble of conflicting qualities and emotions. Although her career was still "bombing ahead," the private woman retreated into a cocoon of self-doubt. In her 1987 painting *Salmon Between Two Sinks,* Pratt appears to be expressing the inconsistency of her life, between private disappointment and public acceptance. Like the salmon, Pratt was suspended between two incongruous dimensions, one clouded by the death of innocence, the other swathed in the light of the imagination and the success she was enjoying.

Donna Meaney in front of the billboard-size
reproduction of DECKED MACKEREL

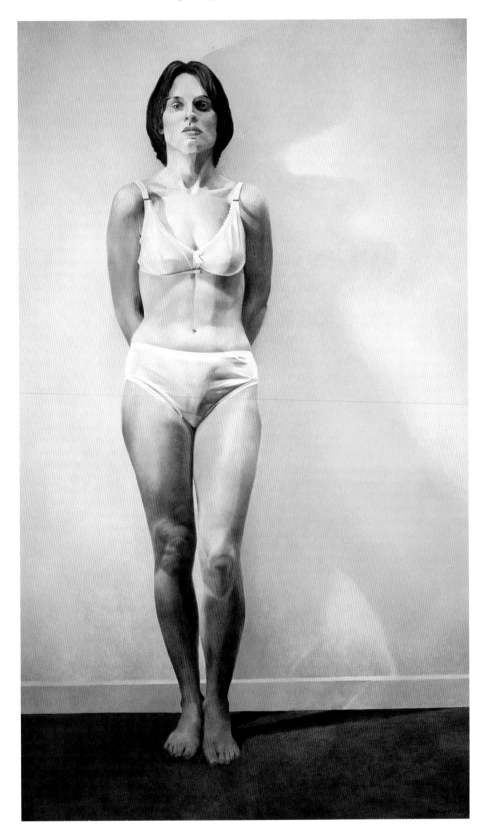

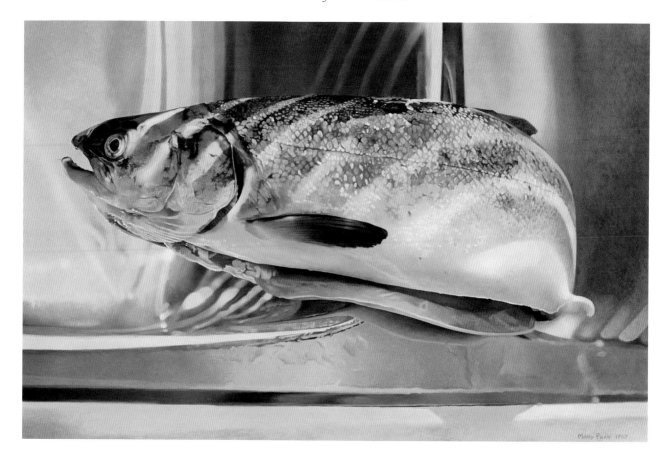

Above: SALMON BETWEEN TWO SINKS, 1987
oil on masonite, 72.4 x 107.3 cm
Private collection

Preceding page: THIS IS DONNA, 1987
oil on canvas, 188.0 x 106.7 cm
Collection of Jim Coutts

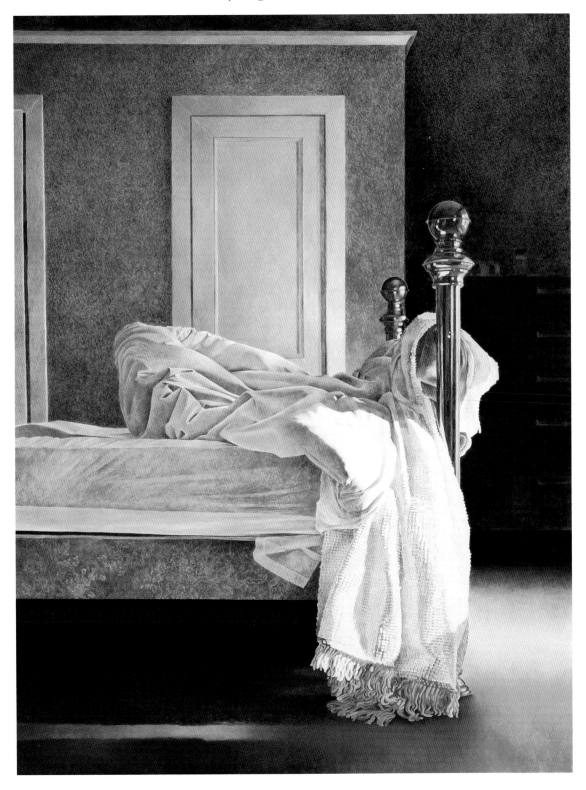

BEDROOM, 1987
oil on masonite, 121.9 x 88.2 cm
Private collection

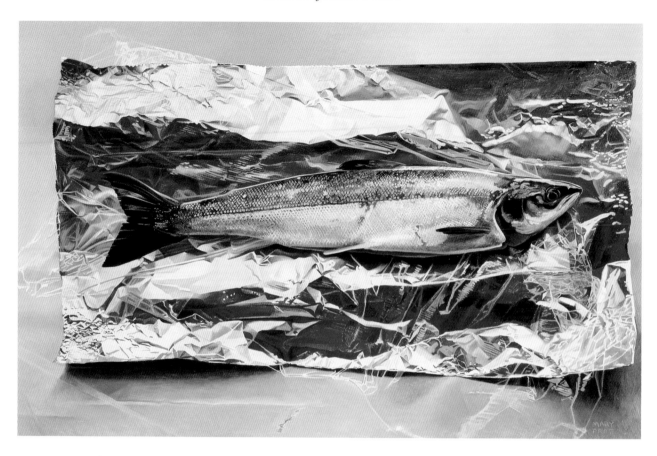

SILVER FISH ON CRIMSON FOIL, 1987
oil on masonite, 47.0 x 70.0 cm
Collection of Mr. and Mrs. Ken Soon

A measure of the degree of Pratt's achievement is the fact that she was represented by Mira Godard, who first gave her a solo exhibition in 1985. Pratt admired Godard's self-assurance, poise and business sense. Describing Godard in 1988, Pratt characterized her as "the most complicatedly compassionate and clever and civilized person I have known."[3] Pratt did well at the Mira Godard Gallery, which placed many of her paintings in private, corporate and public collections. Godard also goaded Pratt to push herself artistically, to develop her personal style, technique and subject matter, and to increase the size of her paintings. To move forward as an artist, Pratt looked back by re-interpreting subjects that she had examined earlier in her career. *Bedroom* and *Silver Fish on Crimson Foil* are both variations of the activity of light on surfaces and textures, and both emphasize through their compositions and palettes the undercurrent of violence that was almost entirely camouflaged by the mundanity of the earlier two paintings *The Bed* and *Salmon on Saran*.

In the late 1980s, Pratt continued to explore the identity of the female muse. The issue had preoccupied her for at least the previous decade and she seemed dissatisfied with answers she had found. She investigated expressions of the erotic muse embodied in the subject of *Girl in Glitz*, a 1987 painting translated from a slide taken by her husband. That same year, she interpreted the subject of the creative muse through the theme of the birth of Venus in a painting entitled *Venus from a Northern Pond*, in which the female nude emerges from the depths of the Salmonier River into the bright light, the sunlight glistening off her wet body. However, as diverse as the answers seemed to be, Pratt felt that she had failed to resolve the issue of the personification of the creative muse for women artists and for herself. The moment of revelation occurred when she looked around her, at the subject matter which she had chosen all along, and came to the startling realization that the creative muse for women was objects. "It occurred to me," she recalled, "that maybe women are turned on by objects, the things around them."[4] The "stuff that women collect," she commented, "speaks to women and women give it to men."[5]

This revelation led to images of apocalypse. The portrayal of fruit, as "perfect" as the pomegranates in her 1988 drawing *Pomegranates in a Crystal Bowl*, gave way to images of fire.[6] One of Pratt's earliest images of fire was her 1981 painting *Fire Barrel*, showing a disposal drum sitting in the snow containing a fire burning "yesterday's mistakes from the studio." An image of two states of matter — ice and fire — the painting is an emblem of the end of time. Referring to a poem by Robert Frost, *Fire Barrel* encapsulates two different beliefs that the world will end in conflagration by fire or by being encased in

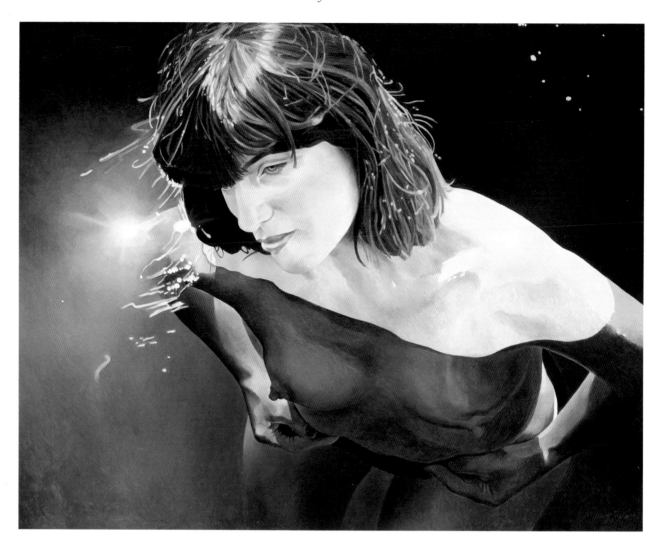

VENUS FROM A NORTHERN POND, 1987
oil on masonite, 64.8 x 81.3 cm
Private collection

ice.[7] Through her representations of fires and bonfires, Pratt explored the theme of the end of things, destroyed, offered up or incinerated.

Pratt found the representation of fire to be liberating and "great fun."[8] "The fire had to be alive," she commented, and this required an adjustment in her use of media and a change in her personal style. Rather than confine herself to the use of oil paint when describing fire, Pratt combined watercolour, pastel and chalk in multi-media drawings on large paper. The change in media and format, adapted to the new subject, allowed her actively and physically to engage in the process of creation. She could stand at her easel, move around, use her whole arm and body to make marks on the paper. In the past, she was interested in describing the effects of light on surfaces. In the bonfire drawings, she was able to represent light itself at the moment of its creation as it consumes matter. The creative and phenomenal processes join in describing the paradoxical relationship between the revelatory qualities of light and the apocalyptic associations it is intended to call to mind. Pratt's fires embody such diverse connotations as ritualistic sacrifice, purifying immolation and eternal damnation.

In the 1988 drawing *Bonfire by the River*, she experimented with mixing water- and oil-based media to create a dynamic image of a roaring fire at its height. Process and media allowed her to capture the ephemeral quality of fire, its fluting tongues and the energy and heat of the transformation of matter into flames. Against a dark background, the fire is thrown into high relief through the device of a contrasting foil.

The bonfire at night is also the subject of the 1989 drawing *Bonfire with a Beggar Bush* and *Burning the Rhododendron*, drawn the following year. In Pratt's hands, both drawings become the pure expression of light. Light radiates from the centres of the fires, shown as a white presence almost blinding in its intensity. The nocturnal landscapes are studies in mauves, violets and purples interacting in subtle gradations of hue that contrast with the oranges and yellows of the fire. The effect sets up a dynamic, vibrating surface, created by the complementary contrasts and the optical illusions caused by after-images. The optical vibrato is accentuated by the strokes and marks of the media charting the process of creation. In stark contrast, in 1989 Pratt created the large-format drawing *Snow Blower on Table Mountain*, describing the phenomenal opposite of her fire drawings. In this work, the blinding intensity of the light radiates from the centre of the blowing snow and ice. Fire and ice both become elements through which Pratt explores the refraction of light and the incarnation of her muse as a presence radiating from the centres of the phenomena.

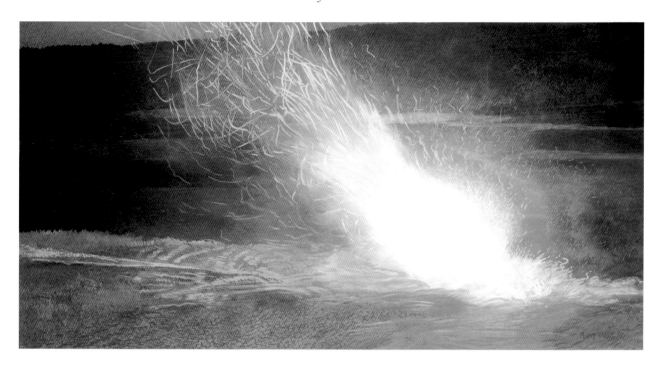

BURNING THE RHODODENDRON, 1990
watercolour and pastel on paper, 127.6 x 239.4 cm
Collection of Sun Life Assurance Company of Canada

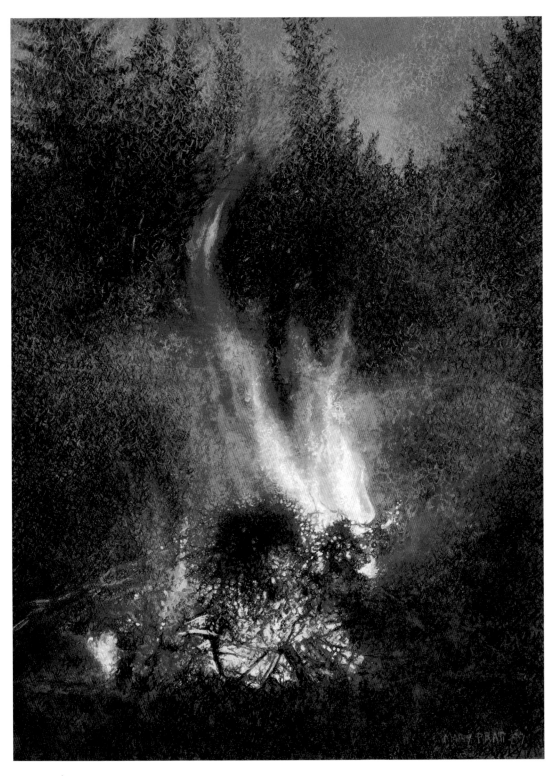

BONFIRE WITH BEGGAR BUSH, 1989
watercolour and pastel on paper, 110.0 x 77.8 cm
Private collection, New Brunswick

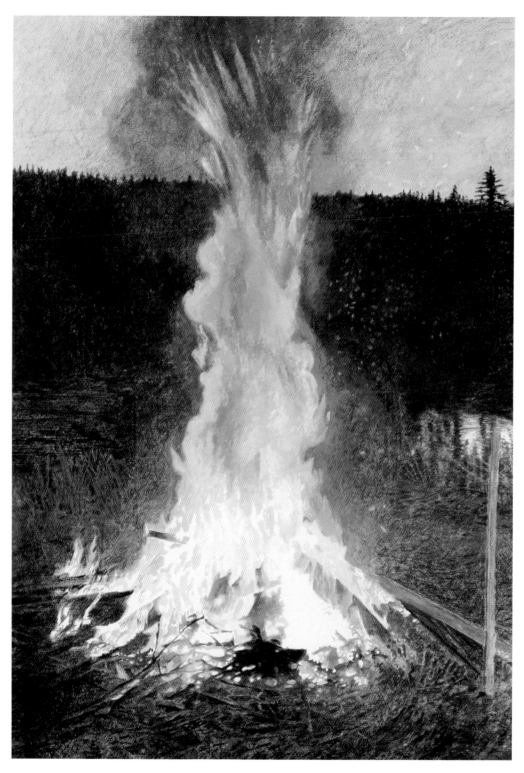

BONFIRE BY THE RIVER, 1988
watercolour and pastel on paper, 124.1 x 84.1 cm
Private collection, Vancouver

Although the fire drawings were exhibited at the Mira Godard Gallery in 1989, they became better known following the publication that year of a book dealing with Pratt's life and art by Sandra Gwyn and Gerta Moray.[9] *Mary Pratt* marked her growing importance in the visual arts. That her work was both popular and resonant with meaning is reflected in the two essays published in the book — Gwyn's discussion of her art using a biographical framework and Moray's analysis of it in art-historical and critical contexts. The division of approaches in itself reflects Pratt's place on the cultural stage: accessible on many different levels to a variety of audiences and readers.

Gwyn's "Introduction" traces a career curve that is also an experiential one. She describes Pratt's development as artist in relationship to significant events in her life — her youth in New Brunswick, her marriage in Newfoundland — and works of art that proved to be turning points. Moray's "Critical Essay" explores the many different meanings of the imagery, asserting that Pratt "invaded" the realm of the ideal through a strategy of subversion. The mundanity of her subject matter, presented in a naturalistic style normally conscripted by artists for idealistic themes, undermines naturalism's authority as the mode of representation suitable for edifying subjects. Pratt has the temerity, Moray suggests, to present profane mundanity as if it was sacred prescience. Within this paradox, Moray discussed the "politics" of Pratt's imagery.

By 1990 Pratt had found a popular audience and her work was taken as seriously as that of her contemporary in Canadian literature, Alice Munro. Both artists explore the universality of particularities, and it is tempting to see their works as analogous. Pratt's 1986 painting Wedding Dress was reproduced on the cover of Munro's book of stories *Friend of My Youth*. But whereas the narrative quality of Pratt's art revolves around the transformation of images into metaphors and symbols through the power of imaginative

Detail showing the application of media in BONFIRE BY THE RIVER

SNOW BLOWER ON TABLE MOUNTAIN, 1989
watercolour and pastel on paper, 125.7 x 200.7 cm
Private collection, New Brunswick

association and non-linear thought, Munro's stories circle around the motivations of characters coming to terms with hidden dimensions of the human heart. Revelation in Pratt's art is a result of seeing the image as a dense construction of possible meanings; in Munro's prose, revelation occurs as a result of peeling away layers of human experience to understand the truth.[10]

Largely as a result of Pratt's growing popular acclaim and critical attention, art historians in the early 1990s began to situate her art within the traditions of east coast Canadian art, seeing it as a foil to that of her husband. Her art was often described as the antithesis of Christopher's — she tending toward "emotive realism," he toward "cool abstraction."[11] Her life and work were viewed as emblems of the experience of modern women, exacting records of the manner in which women of Pratt's generation viewed the world and lived within society's conventions. That Pratt's work was being tentatively compared to that of Miller Brittain, Alex Colville and Tom Forrestall reflected a growing desire to synthesize east coast modernism into a coherent pattern that too often has been casually placed under the imprecise umbrella of "magic realism." The term "realism" itself had been examined in order to codify its stylistic attributes more precisely than before. Pratt's art was seen to be part of a search for new definitive forms of that tradition.[12] The inclusion of Pratt's fire drawings in *The Tenth Dalhousie Drawing Exhibition* underlined the fact that they did not perpetuate biases concerning realism, especially in the process of their creation. The drawings were also seen as a departure from Pratt's usual domestic subject matter.[13]

It is precisely by recording details of still life and landscape that Pratt directly confronted her muse in several paintings and drawings of the early 1990s. In *Fruit and Lobelia* (1989) and *Picnic with a Pineapple* (1991), she created sensual essays of light falling on a variety of natural forms. Her beautifully evocative display of intense outside light reflecting off surfaces virtually causes forms to dissolve and the light to dance in the imaginative space of the viewer. Light enfolding substance becomes a radiant presence in her still lifes of this time, among them the 1992 painting *Reflections of the Florentine in the Salmonier* and *Fruitcake, Very Dark, Very Rich* of the following year.

But in its radiance, the light cast into relief the dark themes that had preoccupied the artist since 1969. By choosing to develop as an artist, Pratt looked back first to her treatment of the theme of violence and second to her childhood. By the mid-1990s her art had moved full circle. In her still lifes of the early 1990s, Pratt once again presented

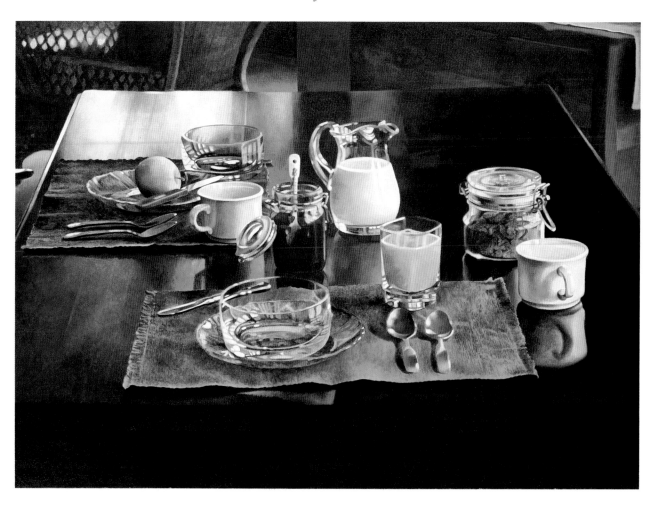

BREAKFAST LAST SUMMER, 1994
oil on canvas, 91.4 x 121.9 cm
Courtesy of the Equinox Gallery, Vancouver

metaphors of domestic aggression through her art. This time, however, these were more subtle than the earlier images of gutted fish, flayed fowl or suspended carcasses. The cutting and preparation of fruit carried the weight of the violent subtext. Paradoxically, these dark undercurrents were submersed in images of extraordinary beauty and visual seduction. In *Green Grapes and Wedding Presents with Half a Cantaloup*, Pratt emphasizes the sensuality of the surfaces of the fruit and silver in an elegantly composed arrangement that draws the eye through the concentric rings to the centre of the cleaned fruit and back out again with the reflected light. *Pomegranates in Glass on Glass* (1993) reinterprets the theme of sexual aggression as the cutting of fruit. The dark background throws into relief the exposed fruit and seeds whose colour alludes to a bloodletting expressed in the simple act of cutting fruit. *Emmenthal Cheese in Saran* echoes a similar subtext of fatal violence expressed as the smothering of cheese to prevent its spoilage; in *For the Love of These Oranges* and *Glassy Apples,* the soft fruit exposed under the skin is a subtle metaphor of violation.

Pratt's continuing interest in reinterpreting subjects that she treated earlier in her career led her to examine her 1969 painting *Supper Table* and to recast it to reflect her personal circumstances. Just as the earlier painting was an autobiographical statement, a fugitive moment caught in the chaos of her life, Pratt sought to give form to the condition that she found herself in after her children left the household and after she and her husband chose to live apart. Pratt's two 1994 paintings *Breakfast Last Summer* and *Dinner for One* describe the movement in her life toward living alone. With both, there is a sense of control, a disciplined balance of elements described by Pratt as the harmonic relationships between utensils, jelly jars, vessels and plates. Light enters the compositions from the back and is reflected forward off the surfaces of the tables directly into the viewer's space, in front of whom places have been set.

A series of paintings that Pratt created in early 1995 were based on exploring memories of her childhood in Fredericton and her life in her parents' home. Two earlier drawings, *Botanic Gardens* (1989) and *To Glasgow* (1990), looked back on her experience of Scotland more than thirty years earlier; through the paintings that comprised the exhibition *The House Inside My Mother's House*, Pratt sought to understand her childhood and the source of her creativity. Her past, it would seem, is coloured by the blood red carpet of her parents' home, the dense claustrophobia of their dining room, the humidity of her parents' bedroom, the dollhouse at the top of the stairs (a replica of her parents' own house). By walking through the rooms of her past, Pratt exposes the

charm and rectitude of her father, the private, enigmatic presence of her mother, and the dignified comportment of her grandmother. She gives witness to the warmth and quality of light of a Fredericton morning nearly fifty years earlier.

Looking back, the Memorial University orator's admonishment to the Chancellor "not to be deceived by the woman standing patiently before you" could equally apply to Mary Pratt's art, which, like the woman herself, is not what it appears to be at first glance. Her art is still changing. She has begun an ambitious suite of ten limited-edition woodblock prints of still lifes, each containing more than one hundred separate colours. Her primary focus, however, has remained constant. She is not interested merely in turning the articles and rituals of domesticity into a myth of her creative life. The myth that Pratt has developed expresses the incarnations of a radiant muse in her art. Her art structures her life, giving clarity, meaning and order to its paradoxes, its highlights and its dark tonalities. Each object of Pratt's world establishes itself by its presence. And yet, each object is poised to be metamorphosed into another form, a new beginning, through intense awareness triggered by the enlivening, sensual activity of light on surfaces. Pratt's ability to recreate this experience as art transforms the myth into her life.

DINNER FOR ONE, 1994
oil on canvas, 61.0 x 91.4 cm
Private collection, Vancouver

FRUIT AND LOBELIA, 1989
watercolour and pastel on paper, 75.6 x 112.4 cm
Collection of Jannock Ltd.

PICNIC WITH A PINEAPPLE, 1991
oil on canvas, 60.6 x 91.5 cm
Private collection, New Brunswick

REFLECTIONS OF THE FLORENTINE IN THE SALMONIER, 1992
oil on canvas, 50.8 x 76.2 cm
Collection of Dr. and Mrs. Peter C. Chan

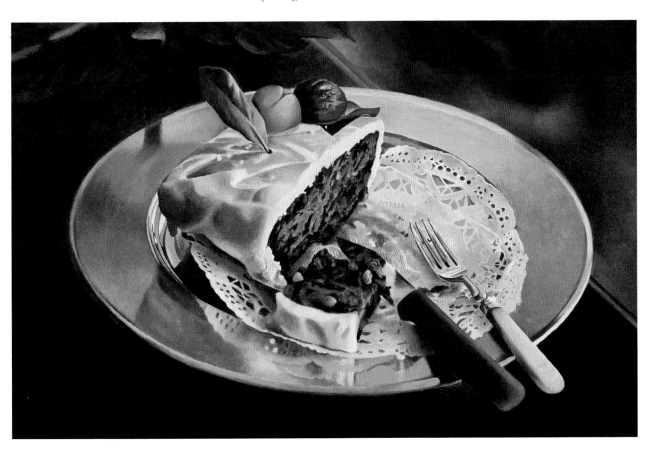

FRUITCAKE, VERY DARK, VERY RICH, 1993
oil on linen, 50.8 x 76.2 cm
Private collection

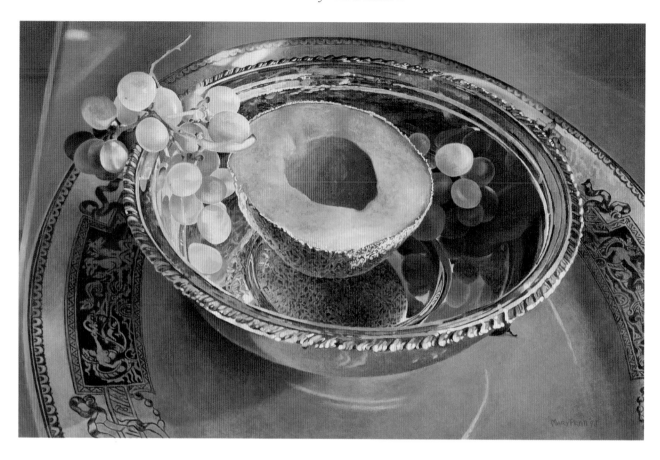

GREEN GRAPES AND WEDDING PRESENTS WITH HALF A CANTALOUP, 1993
oil on canvas, 61.0 x 91.4 cm
Private collection

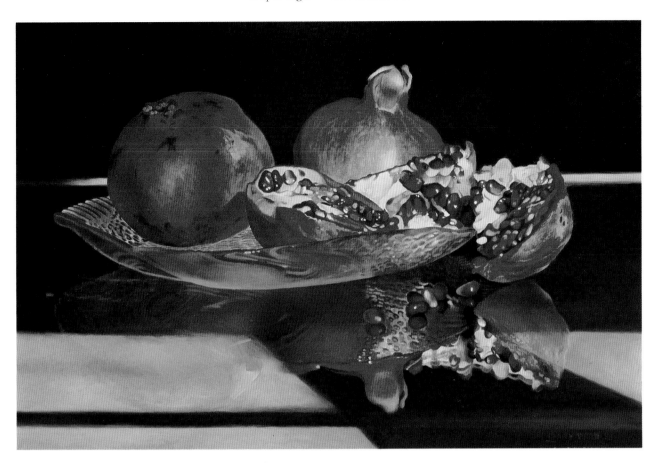

POMEGRANATES IN GLASS ON GLASS, 1993
oil on panel, 40.6 x 58.4 cm
Private collection

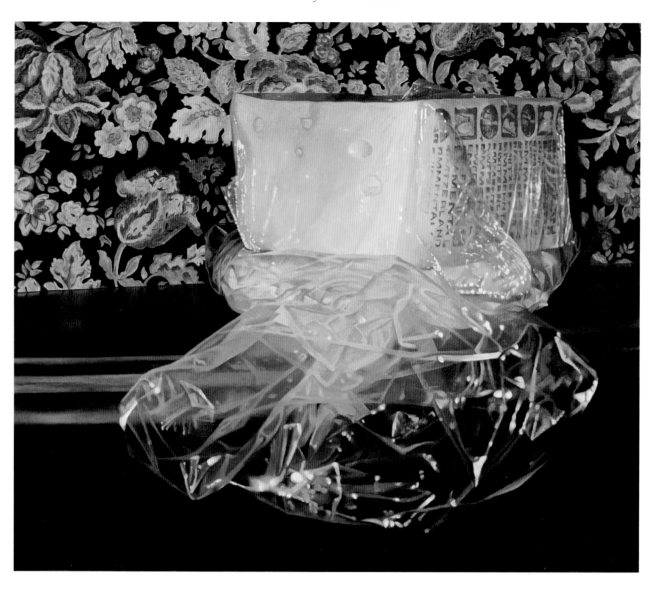

EMMENTHAL CHEESE IN SARAN, 1993
oil on linen, 71.1 x 81.3 cm
Collection of Kathleen L. Mitchell

FOR THE LOVE OF THESE ORANGES, 1994
oil on panel, 61.0 x 67.3 cm
Private collection

GLASSY APPLES, 1994
oil on canvas, 45.7 x 61.0 cm
Collection of Harrison McCain

Notes

Chapter One ∞ FREDERICTON

1. Pratt, writing about her upbringing in Fredericton, undated MS in her personal papers.

2. Gary Michael Dault, "'I like paint better than realism,'" *Toronto Star*, May 6, 1978.

3. See bibliography.

4. Pratt, writing about her upbringing in Fredericton, undated MS in her personal papers.

5. *Ibid*.

6. Suzanne MacKay, "Women Artists in Canada: An Atlantis Gallery of Women's Art," *Atlantis* 5 (fall 1979).

7. Allen Bentley, "50 Years: The UNB Art Centre," *Arts Atlantic 41*, 11, no.1 (fall 1991): 44-45.

8. Helen Duffy and Frances K. Smith, *The Brave New World of Fritz Brandtner* (Kingston: Agnes Etherington Art Centre, Queen's University, 1982): 40.

9. Pratt, interview by author, Fredericton, May 31, 1994.

Chapter Two ∞ MOUNT ALLISON

1. Duffy and Smith, *The Brave New World of Fritz Brandtner*, 42.

2. Douglas Lochhead, "Lawren P. Harris — A Way to Abstract Painting," *Canadian Art* 12, no.1 (autumn 1954): 67.

3. Mount Allison University, *Calendar 1953-54*.

4. Gemey Kelly, "The Historical Period, 1854 - 1945," *Atque Ars: Art from Mount Allison University, 1854-1989* (Sackville: Owens Art Gallery, Mount Allison University, September 30 - October 31, 1989): 18.

5. John G. Reid, *Mount Allison University: A History, to 1963* (Toronto: University of Toronto Press, 1984), 2:258.

6. *Calendar 1953-54*.

7. Louis Rombout, "Lawren Harris: Profile of a Painter," *Atlantic Advocate* (December 1964): 56.

8. *Ibid.*, 57.

9. Lochhead, "Lawren P. Harris," 64-66.

10. *Ibid.*, 67.

11. Lawren P. Harris, "A Statement by the Painter," catalogue hand list printed by the New Brunswick Museum Art Department to coincide with an exhibition of his paintings and drawings (February 1954).

12. Lochhead, "Lawren P. Harris," 67.

13. *Ibid.*

14. Pratt, *Journal*, June 5, 1994.

15. Helen J. Dow, "The Magic Realism of Alex Colville," *Art Journal* 24, no. 4 (summer 1965): 318-329; and Dow, *The Art of Alex Colville* (Toronto: McGraw-Hill Ryerson, 1972): 101-104, trace the origins of the term "magic realism."

16. David Burnett, *Colville* (Toronto: Art Gallery of Ontario and McClelland & Stewart, 1983), 111.

17. Christopher Pratt, "Introductory Comments," *Edward B. Pulford* (Sackville: Mount Allison University, 1980).

18. Stephen Kimber, "Who's Ted Pulford? He's 'an unsung hero,' that's who," *Atlantic Insight* (June 1980): 56.

19. Pratt, *Journal*, undated entry from 1977.

20. *Calendar 1953-54.*

21. Pratt, interview by author, Fredericton, May 31, 1994.

22. Pratt's first class with Harris occurred at the end of her freshman year when she was allowed to participate in one of his portrait studios over a two-week period.

23. Pratt, telephone interview by author, November 1, 1994.

24. Pratt, *Journal*, June 5, 1994.

25. *Ibid.*

26. *Ibid.*

27. Pratt, telephone interview by author, March 7, 1995.

Chapter Three ∽ *SALMONIER*

1. Pratt, telephone interview by author, March 7, 1995.

2. Pratt, *Journal*, August 30, 1977.

3. *Ibid.*

4. Morgan Annan, "Mary and Christopher Pratt," *Newfoundland Lifestyles* (August-September 1984): 25-28.

5. *Ibid.*

6. Pratt, *Journal*, August 30, 1977.

7. Pratt, *Journal*, June 5, 1994.

8. Pratt, interview by author, Fredericton, May 31, 1994.

9. Eve Drobot, "Behind every successful woman there is . . . a man?" *Homemaker's 2*, no. 5 (September 1976): 44-47.

10. *Ibid.*

11. "Joan Murray Talking with Mary Pratt," *Arts Atlantic 2*, no. 1 (spring 1979): 35.

12. Sandra Gwyn, "Introduction," *Mary Pratt* (Toronto: McGraw-Hill Ryerson, 1989), 10.

13. "Working at Home: An interview with Mary Pratt," *Banff Letters* (spring 1985): 8-11.

14. Pratt, interview by author, Fredericton, June 1, 1994.

15. *Ibid.* "From away" is a pejorative term to describe people who have moved to the region from another part of Canada and who, consequently, do not have roots in the province.

16. Pratt, telephone interview by author, March 7, 1995.

17. *Ibid.*

18. Rae Perlin, "Mary Pratt: 'Delicate and sensitive,'" *Evening Telegram* (St. John's), March 25, 1967.

19. Pratt, interview by author, Fredericton, May 31, 1994.

20. "Joan Murray Talking with Mary Pratt," 35.

21. *Ibid.*

22. Pratt, interview by author, Fredericton, 31 May 1994.

23. Pratt, interview by author, Fredericton, 1 June 1994.

24. Gwyn, "Introduction," 12.

25. *Ibid.*

26. *Ibid.*

Chapter Four ⌛ *NEW REALISM*

1. "Joan Murray Talking with Mary Pratt," 37.

2. *Ibid.*

3. In 1964, Pratt was commissioned to design and prepare maps, drawings and diagrams for *The Snipe* by Leslie M. Tuck, a former Dominion Wildlife Officer.

4. Pratt, interview by author, Fredericton, June 1, 1994.

5. "Joan Murray Talking With Mary Pratt," 39.

6. Gwyn, "Introduction," 11-12.

7. Pratt, interview by author, Fredericton, June 1, 1994.

8. Linda Chase, *Hyperrealism* (New York: Rizzoli, 1975), 12

9. Linda Nochlin, "The New Realists," *Realism Now* (Poughkeepsie: Vassar College Art Gallery, May 8 - June 12, 1968): 9.

10. Nochlin quoting Alain Robbe-Grillet in "The New Realists," 10-11.

11. Chase, 12.

12. Bruce Morrissette, *The Novels of Alain Robbe-Grillet* (Ithaca: Cornell University Press, 1963): 26.

13. Patricia A. Deduck, *Realism, Reality, and the Fictional Theory of Alain Robbe-Grillet and Anais Nin* (Washington: University Press of America, 1982): 63.

Chapter Five ⌛ *CELEBRATION*

1. Pratt, interview by author, Fredericton, June 1, 1994.

2. Saint John, Morrison Gallery, November 1969, *Mary Pratt*; Toronto, Picture Loan Gallery, February 5 - 20, 1971, *Painters in Newfoundland*; Saint John, Morrison Gallery, November 17 - 29, 1971, *Mary Pratt.*

3. Peter Wilson, "Fifteen artists have captured the flavour of Newfoundland," *Toronto Daily Star*, 13 February 1971, p. 63.

4. St. John's, Memorial University of Newfoundland Art Gallery, July 1973, *Mary Pratt: A Partial Retrospective*; Memorial University of Newfoundland Art Gallery, June - July, 1975, *Mary Pratt: Paintings and Drawings.*

5. "Mary Pratt on Mary Pratt: Excerpts from a conversation with Sandra Gwyn," published in a brochure for the exhibition *Mary Pratt: Paintings and Drawings* (St. John's: Memorial University of Newfoundland Art Gallery, June - July, 1975).

6. Pratt, interview by author, Fredericton, June 1, 1994.

7. "Mary Pratt on Mary Pratt: Excerpts from a conversation with Sandra Gwyn."

8. *Ibid.*

9. *Ibid.* Pratt comments, "Every painting that's really been successful comes from something I've seen accidentally."

10. Peter Bell, "Introduction," *Mary Pratt: A Partial Retrospective* (St. John's: Memorial University of Newfoundland Art Gallery, June 26, 1973).

11. "Mary Pratt on Mary Pratt: Excerpts from a conversation with Sandra Gwyn."

12. *Ibid.*

13. Harry Bruce, "The Fine Art of Familiarity: Mary Pratt paints as she lives — close to her kitchen sink," *Canadian* (November 29, 1975): 17.

14. Pratt, interview by author, Fredericton, June 1, 1994.

15. Mayo Graham, "Some Canadian Women Artists," *Art Magazine* (December 1975/January 1976): 12-17; Pratt's comments are published in Graham, *Some Canadian Women Artists* (Ottawa: The National Gallery of Canada, 1975): 56.

16. Pratt, quoted in Graham, *Some Canadian Women Artists*, 55.

17. *Ibid.*, 16.

18. *Ibid.*, 19.

19. Robert Fulford, "There is a distinct 'female art' insists organizer of women's show," *Toronto Star*, December 6, 1975.

20. Georges Bogardi, "Women's art lost in issues," *Montreal Star*, 29 November 1975, p. D6; Fulford, "There is a distinct 'female art' insists organizer of women's show."

21. James Purdie, "Sense of wonderment from women painters," *Globe and Mail*, November 24, 1975.

22. Susan Hallett, "Mary Pratt: The Redeeming Realist," *Canadian Review* (May 1976): 52.

23. Peter Bell, "Exhibition offered sense of belonging," *Evening Telegram* (St. John's), November 29, 1975.

24. Pratt, interview by author, Fredericton, June 1, 1994.

Chapter Six ∾ *ENGAGEMENT*

1. Robert Fulford, "A Note on Mary Pratt," *Mary Pratt: Paintings — A Seven Year Survey* (Toronto: Aggregation Gallery, February 21 - March 11, 1976).

2. *Ibid.*

3. Pratt, interview by author, Fredericton, June 1, 1994.

4. Pratt, commenting on *Service Station*, in Gwyn and Moray, *Mary Pratt*, 94.

5. "Joan Murray Talking with Mary Pratt," 39.

6. *Service Station* was shown in the exhibition *Mary Pratt: New Paintings and Drawings* (Toronto: Aggregation Gallery, April 29 - May 17, 1978).

7. James Purdie, "Realist takes a step toward the surreal," *Globe and Mail*, May 6, 1978.

8. Pratt, *Journal*, undated entry from 1977.

9. "Joan Murray Talking with Mary Pratt," 41.

10. *Ibid.*

11. *Ibid.*

12. Gwyn and Moray, *Mary Pratt*, 96.

13. Pratt, interview by author, Fredericton, June 1, 1994.

14. Joyce Zemans, *Christopher Pratt* (Vancouver: Vancouver Art Gallery, November 23, 1985 - January 26, 1986): 45.

15. *Ibid.*, 55.

16. Toronto, Aggregation Gallery, January 8 - February 10, 1977, *Mary Pratt, Bruce St. Clair, Robert Sinclair*; Aggregation Gallery, April 29 - May 17, 1978, *Mary Pratt: New Paintings and Drawings.*

17. "Joan Murray Talking with Mary Pratt," 34-41.

Chapter Seven ∞ TRANSFORMATION

1. Pratt, interview by author, Fredericton, June 1, 1994.

2. The exhibition *Mary Pratt: A Partial Retrospective* (St. John's: Memorial University of Newfoundland Art Gallery, July, 1973), toured throughout the Atlantic Provinces, and the exhibition *Mary Pratt: Paintings and Drawings* (St. John's: Memorial University of Newfoundland Art Gallery, June - July, 1975), toured to galleries in Halifax and Fredericton, to Simon Fraser University, and thereafter through British Columbia.

3. Joan Murray, "Mary Pratt: The Skin of Things," *Mary Pratt* (London Regional Art Gallery, June 19 - August 16, 1981).

4. *Ibid.*

5. Josephine Cheeseman, "Mary Pratt dislikes image as 'martyr,'" *Daily News* (St. John's), August 8, 1981.

6. Pratt, commenting in Gwyn and Moray, 124.

7. *Ibid.*, 126.

8. Anne Collins, "Mary Pratt: In and out of the kitchen," *City Woman* (summer 1982): 54.

9. Pratt, quoted in Peter O'Brien, ed., "An Interview with Mary Pratt," *Rubicon* 5 (summer 1985): 42.

10. *Ibid.*, 28.

11. *Ibid.*

12. *Ibid.*, 41 - 42.

13. Vancouver, Elizabeth Nichol's Equinox Gallery, October 9 - 31, 1986, *Mary Pratt: Aspects of a Ceremony.*

14. Pratt, note to the author, April 4, 1995.

17. Pratt, *Journal*, August 8, 1986.

Chapter Eight ∽ REVELATION

1. Collins, "Mary Pratt: In and out of the kitchen"; Annan, "Mary and Christopher Pratt," to name just two.

2. Pratt, *Journal*, April 30, 1984.

3. Pratt, *Journal*, March 12, 1988.

4. Christopher Hume, "Mary Pratt: Turning on to everyday objects," *Art Impressions* (summer 1988): 20-22.

5. Pratt, interview by author, Fredericton, June 2, 1994.

6. Pratt, commenting in Gwyn and Moray, 178.

8. Pratt, interview by author, Fredericton, June 2, 1994.

9. Toronto, Mira Godard Gallery, May 4 - 31, 1989, *Mary Pratt: Flames*; Gwyn and Moray, *Mary Pratt*.

10. Martha Muzychka, "Alice Munro's truth-revealing style wins again," *Sunday Express* (St. John's), August 12, 1990.

11. Maurice Yacowar, "The Paintings of Mary (vs. Christopher) Pratt," *Dalhousie Review* 68, no. 4 (winter 1988-89): 385-399.

13. Susan Gibson Garvey, *The Tenth Dalhousie Drawing Exhibition* (Halifax: Dalhousie Art Gallery, April 7 - May 13, 1990): 11.

Chronology and Exhibition History

1935 Born on March 15 in Fredericton, New Brunswick.

1950 Attends summer classes at the Art Centre, University of New Brunswick.

1951-52 Attends evening classes given by John Todd in Fredericton.

1953 Enrols in the Bachelor of Fine Arts programme at Mount Allison University,
 Sackville, New Brunswick.

1956 Graduates in the spring with a Certificate in Fine Arts from Mount Allison
 University.

 Moves to St. John's, Newfoundland, and works as an occupational therapist.

1957 Marries Christopher Pratt in September.

 Moves to Glasgow where Christopher studies at the Glasgow School of Art.

1958 Travels to St. John's in the spring.

 Returns to Glasgow in the late summer where Christopher studies at the
 Glasgow School of Art for a second year.

1959 Returns to Sackville and enrols in the fourth year of the Bachelor of Fine
 Arts programme at Mount Allison University.

1961 Graduates from Mount Allison University with a Bachelor of Fine Arts
 degree.

 Moves to St. John's and teaches painting at Memorial University of
 Newfoundland in the Extension Department.

1963 Moves to Salmonier, Newfoundland.

1967 St. John's, Memorial University of Newfoundland Art Gallery, March,
 Mary Pratt (solo).

1969 Paints *Supper Table.*

 Saint John, New Brunswick, Morrison Gallery, November, *Mary Pratt* (solo).

1970 Ceases painting in September and takes sewing classes. During the Christmas
 holiday her family convinces her to finish the painting *Eviscerated Chickens.*

1971 Toronto, Picture Loan Gallery, February 5 - 20, *Painters in Newfoundland*
 (group).

 Saint John, Morrison Gallery, November 17 - 29, *Mary Pratt* (solo).

1973 Toronto, Erindale College, University of Toronto, March 26 - April 23,
 Mary Pratt: Paintings (solo).

 St. John's, Memorial University of Newfoundland Art Gallery, July,
 Mary Pratt: A Partial Retrospective (solo, provincial touring exhibition).

1974 Sackville, New Brunswick, Owens Art Gallery, April 1 - May 15, *The Acute
 Image in Canadian Art* (group).

 Vancouver, Vancouver Art Gallery, *SCAN* (Survey of Canadian Art Now)
 (group).

Hamilton, Art Gallery of Hamilton, *9 out of 10: A Survey of Contemporary Canadian Art* (group, provincial touring exhibition).

1975 Toronto, Art Gallery of Ontario, Art Rental Gallery, April 5 - May 6, *Through the Looking Glass Towards a New Reality* (group).

St. John's, Memorial University of Newfoundland Art Gallery, May 30 - June 28, *Mary Pratt at Home* (solo).

St. John's, Memorial University of Newfoundland Art Gallery, June-July, *Mary Pratt: Paintings and Drawings* (solo).

Ottawa, National Gallery of Canada, November 20 - January 13, 1976, *Some Canadian Women Artists* (group).

Halifax, Dalhousie University Art Gallery, December 10 - 28, *Mary Pratt* (solo).

1976 Toronto, Aggregation Gallery, February 21 - March 11, *Mary Pratt: Paintings — A Seven Year Survey* (solo).

Stratford, The Gallery, June 8 - September 5, *Aspects of Realism* (group, national touring exhibition)

1977 Toronto, Aggregation Gallery, January 8 - February 10, *Mary Pratt, Bruce St. Clair, Robert Sinclair* (group).

Fredericton, The Beaverbrook Art Gallery, July, *50 Canadian Drawings* (group).

Toronto, Harbourfront Art Gallery, *Selecting and Collecting* (group).

1978 Paints *The Service Station* and *Girl in Wicker Chair.*

Toronto, Aggregation Gallery, April 29 - May 17, *Mary Pratt: New Paintings and Drawings* (solo).

Regina, Norman Mackenzie Art Gallery, University of Saskatchewan, June 2-21, *Realism in Canada: Traditional and New* (group).

1979 Toronto, Factory 77, May 5 - June 2, *The Work of Art — Realism* (group).

Charlottetown, Confederation Centre Art Gallery, September 5 - 30, *Aggregation Gallery at the Confederation Art Gallery* (group).

1980 Oshawa, Robert McLaughlin Gallery, March 4 - 30, *12 Canadian Artists* (group).

1981 Toronto, Aggregation Gallery, May 23 - June 10, *Mary Pratt: Recent Paintings and Works on Paper* (solo).

London, Ontario, London Regional Art Gallery, June 19 - August 16, *Mary Pratt* (solo, national touring exhibition).

St. John's, Memorial University of Newfoundland Art Gallery, *Drawings from the Permanent Collection* (group).

1984 Kamloops, Kamloops Public Art Gallery and Kamloops Museum and Archives, September 6 - 30, *A Fish Story* (group).

1985 Toronto, Mira Godard Gallery, May 4 - 22, *Mary Pratt* (solo).

Vancouver, Elizabeth Nichol's Equinox Gallery, November 21 - December 24, *Food: A Thematic Group Exhibition* (group).

1986 St. John's, Memorial University of Newfoundland Art Gallery, July 24 - August 31, *Twenty-five Years of Art in Newfoundland: Some Significant Artists* (group, travelling).

Vancouver, Elizabeth Nichol's Equinox Gallery, October 9 - 31, *Mary Pratt: Aspects of a Ceremony* (solo).

1987 Toronto, Mira Godard Gallery, November 13 - December 2, *Mary Pratt: Recent Paintings* (solo).

Outdoor sites in Kitchener-Waterloo, Ottawa, Montreal, Vancouver, Calgary, Edmonton, Halifax, Winnipeg and Toronto, *Painting the Town* (group).

1988 Vancouver, Equinox Gallery, April 7 - 30, *Robert Michener, Mary Pratt, Katherine Surridge* (group).

St. John's, Memorial University of Newfoundland Art Gallery, May 19 - July 3, *St. Michael's Printshop* (group).

Edmonton, Woltjen/Udell Gallery, November 19 - December 3, *Large Work on Paper* (group).

Fredericton, Gallery 78, November 25 - December 10, *Artists of Newfoundland* (group).

1989 Vancouver, Equinox Gallery, May 4 - 31, *Mary Pratt: New Work* (solo).

Toronto, Mira Godard Gallery, December 2 - 23, *Mary Pratt: Flames* (solo).

1990 Halifax, Dalhousie Art Gallery, April 7 - May 13, *The Tenth Dalhousie Drawing Exhibition* (group).

St. John's, Memorial University of Newfoundland Art Gallery, April 26 - May 27, *Mary Pratt and John Reeves: The Johnny Wayne Portrait* (group).

1992 Toronto, Mira Godard Gallery, May 30 - June 17, *Mary Pratt: Reflections on the Pond* (solo).

1993 Edmonton, Douglas Udell Gallery, March 13 - April, *Mary Pratt: New Work* (solo).

Vancouver, Equinox Gallery, December 1 - 23, *Mary Pratt* (solo).

1994 Vancouver, Equinox Gallery, December 1 - 31, *Mary Pratt* (solo).

1995 Toronto, Royal Ontario Museum, February 17 - May 23, *Survivors, In Search of a Voice: The Art of Courage* (group, national touring exhibition).

Toronto, Mira Godard Gallery, May 20 - June 10, *Mary Pratt: The House Inside My Mother's House, New Paintings* (solo).

Fredericton, The Beaverbrook Art Gallery, September 16 - November 12, *The Art of Mary Pratt: The Substance of Light* (solo , national touring exhibition).

Bibliography

Annan, Morgan. "Mary and Christopher Pratt." *Newfoundland Lifestyles* (August - September 1984): 25-28.

Bell, Peter. "Exhibition offered sense of belonging." *Evening Telegram* (St. John's), November 29, 1975.

_____. "Introduction." *Mary Pratt: A Partial Retrospective*. St. John's: Memorial University of Newfoundland Art Gallery, 1973.

Bentley, Allen. "50 Years: The UNB Art Centre." *Arts Atlantic 41*, 11, no.1 (fall 1991): 44-45.

Bogardi, Georges. "Women's art lost in issues." *Montreal Star*, November 29, 1975.

Brayshaw, Christopher. "Mary Pratt: Vision to See." *Artichoke* 7, no. 1 (spring 1995): 32-33.

Bruce, Harry. "The Fine Art of Familiarity: Mary Pratt paints as she lives — close to her kitchen sink." *Canadian* (November 29, 1975): 17.

Burnett, David. *Colville*. Toronto: Art Gallery of Ontario and McClelland & Stewart, 1983.

Chase, Linda. *Hyperrealism*. New York: Rizzoli, 1975.

Cheeseman, Josephine. "Mary Pratt dislikes image as 'martyr.'" *Daily News* (St. John's), August 8, 1981.

Collins, Anne. "Mary Pratt: In and out of the kitchen." *City Woman* (summer 1982): 54.

Dault, Gary Michael. "'I like paint better than realism.'" *Toronto Star*, May 6, 1978.

Deduck, Patricia A. *Realism, Reality, and the Fictional Theory of Alain Robbe-Grillet and Anais Nin*. Washington: University Press of America, 1982.

Dow, Helen J. *The Art of Alex Colville*. Toronto: McGraw-Hill Ryerson, 1972.

————. "The Magic Realism of Alex Colville." *Art Journal* 24, no. 4 (summer 1965): 318-329.

Drobot, Eve. "Behind every successful woman there is . . . a man?" *Homemaker's* 2, no. 5 (September 1976): 44-47.

Duffy, Helen and Frances K. Smith. *The Brave New World of Fritz Brandtner*. Kingston: Agnes Etherington Art Centre, Queen's University, 1982.

Fulford, Robert. "A Note on Mary Pratt." *Mary Pratt: Paintings — A Seven Year Survey*. Toronto: Aggregation Gallery, February 21 - March 11, 1976.

————. "There is a distinct 'female art' insists organizer of women's show." *Toronto Star*, December 6, 1975.

Gibson Garvey, Susan, *The Tenth Dalhousie Drawing Exhibition*. Halifax: Dalhousie Art Gallery, 1990.

Graham, Mayo. *Some Canadian Women Artists*. Ottawa: National Gallery of Canada, 1975.

————. "Some Canadian Women Artists." *Art Magazine* (December 1975/January 1976): 12-17.

Grande, John K. "Resurrecting the Images." *Canadian Forum* 69, no. 792 (September 1990): 29-30.

Gwyn, Sandra and Gerta Moray. *Mary Pratt*. Toronto: McGraw-Hill Ryerson, 1989.

Hallett, Susan. "Mary Pratt: The Redeeming Realist." *Canadian Review* (May 1976): 52.

Harris, Lawren P. "A Statement by the Painter." Catalogue hand list printed by the New Brunswick Museum Art Department to coincide with an exhibition of his paintings and drawings (February 1954).

Hume, Christopher. "Mary Pratt: Turning on to everyday objects." *Art Impressions* (summer 1988): 20-22.

Kelly, Gemey. "The Historical Period, 1854 - 1945." *Atque Ars: Art from Mount Allison University, 1854-1989.* Sackville: Owens Art Gallery, Mount Allison University, 1989.

Kimber, Stephen. "Who's Ted Pulford? He's 'an unsung hero,' that's who." *Atlantic Insight* (June 1980): 56.

Kritzwiser, Kay. "Canadian classics in a bullish fling," *Globe and Mail,* April 21, 1973.

Lawrence, Robin. "The Radiant Way." *Canadian Art* 11, no. 2 (summer/June 1994): 26-35.

Lochhead, Douglas. "Lawren P. Harris — A Way to Abstract Painting." *Canadian Art* 12, no.1 (autumn 1954): 64-67.

MacKay, Suzanne. "Women Artists in Canada: An Atlantis Gallery of Women's Art." *Atlantis* 5, (fall 1979).

Molloy, Patricia. "Mary Pratt: Flames." *Arts Atlantic 10,* no. 2 (fall 1990): 3.

Morrissette, Bruce. *The Novels of Alain Robbe-Grillet.* Ithaca: Cornell University Press, 1963.

Mount Allison University, *Calendar 1953-54.*

Murray, Joan. "Joan Murray Talking with Mary Pratt." *Arts Atlantic 2,* no. 1 (spring 1979): 34-41.

_____. "Mary Pratt: The Skin of Things." *Mary Pratt.* London Regional Art Gallery, 1981.

Muzychka, Martha. "Alice Munro's truth-revealing style wins again." *Sunday Express* (St. John's), August 12, 1990.

Nochlin, Linda. "The New Realists." *Realism Now.* Poughkeepsie: Vassar College Art Gallery, 1968.

O'Brien, Paddy. "Mary Pratt." *Canadian Woman Studies/les cahiers de la femme* 3, no. 3 (spring 1982): 36-39.

O'Brien, Peter. "An Interview with Mary Pratt." *Rubicon* 5 (summer 1985): 25-43.

Perlin, Rae. "Mary Pratt: 'Delicate and sensitive.'" *Evening Telegram* (St. John's), March 25, 1967.

Poulter, Gillian. "Mary Pratt: Reflections on the Pond." *Arts Atlantic 45,* 12, no.1 (winter 1993): 15.

Pratt, Christopher. "Introductory Comments." *Edward B. Pulford*. Sackville: Mount Allison University, 1980.

Pratt, Mary and Sandra Gwyn. "Mary Pratt on Mary Pratt: Excerpts from a conversation with Sandra Gwyn." Published in a brochure for the exhibition *Mary Pratt: Paintings and Drawings*. St. John's: Memorial University of Newfoundland Art Gallery, 1975.

Purdie, James. "Realist takes a step toward the surreal."*Globe and Mail*, May 6, 1978.

_____. "Sense of wonderment from women painters." *Globe and Mail*, November 24, 1975.

Reid, John G. *Mount Allison University: A History, to 1963*. Vol. 2. Toronto: University of Toronto Press, 1984.

Rombout, Louis. "Lawren Harris: Profile of a Painter."*Atlantic Advocate* (December 1964): 56-61.

Wilson, Peter. "Fifteen artists have captured the flavour of Newfoundland." *Toronto Daily Star*, February 13, 1971.

"Working at Home: An interview with Mary Pratt." *Banff Letters* (spring 1985): 8-11.

Yacowar, Maurice. "The Paintings of Mary (vs. Christopher) Pratt." *Dalhousie Review* 68, no. 4 (winter 1988-89): 385- 399.

Zemans, Joyce. *Christopher Pratt*. Vancouver: Vancouver Art Gallery, 1985.

Index

This book was designed and typeset by Julie Scriver of
Goose Lane Editions in Fredericton.
Colour separation and printing furnished by
Hemlock Printers Ltd. of Burnaby.

The text face is Venetian 301 issued in digital form by Adobe Systems.
The paper is 110 lb. Eloquence Silk Text.